1
E
D0195987

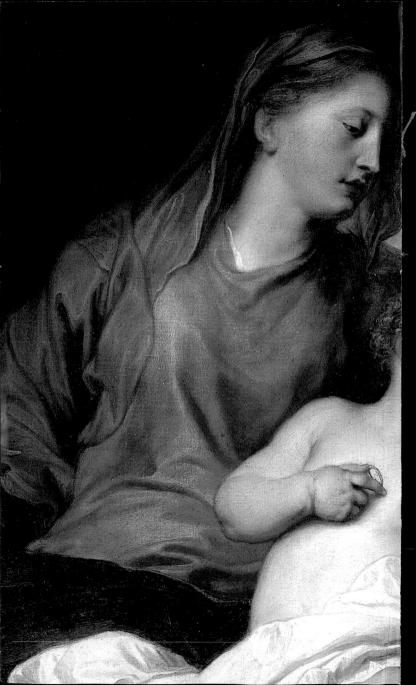

100 Treasures of
Buckingham
Palace

Tom Parsons

With additional entries by
Kathryn Barron
Matthew Winterbottom

Royal Collection Publications

Contents

About the Authors

Tom Parsons lectured in art history at the University of York while engaged in postgraduate research there. He is now a freelance lecturer and writer and works regularly for the National Gallery and the Tate Gallery, London, as well as in Italy. He has published books on Post-Impressionism, Renoir, Rodin and Malevich.

Kathryn Barron is Assistant Curator of Paintings at the Royal Collection. The notes she has written are initialled K.B.

Matthew Winterbottom is Research Assistant in the Works of Art Department at the Royal Collection. His entries are initialled M.W.

Title page illustration:
Anthony Van Dyck, *The Mystic Marriage of St Catherine*

Foreword

The works of art illustrated in this book are amongst the finest of their kind. They form part of the Royal Collection, which is owned by The Queen as sovereign and held in trust for her successors and the nation.

The Royal Collection contains paintings and drawings, furniture, porcelain, silver, sculpture, jewellery, books, arms and armour, and textiles. Most of it is on display or in use at the principal royal residences: these include Buckingham Palace, Windsor Castle, the Palace of Holyroodhouse, St James's Palace, the Tower of London, Hampton Court Palace, Kensington Palace, the Banqueting House, Sandringham House, Balmoral Castle and Osborne House.

Since 1993 a charitable trust, the Royal Collection Trust, has been responsible for the care and conservation of the Collection. The Trust is funded by the income from visitors to the official residences of The Queen (Buckingham Palace, Windsor Castle and the Palace of Holyroodhouse) and does not receive any additional funding from government or other sources.

One of the chief aims of the Royal Collection Trust, of which the Prince of Wales is Chairman, is to ensure that the works of art are presented in ways that will enhance the visitor's understanding and appreciation. A wide-ranging programme of exhibitions and publications is in place to support this important objective.

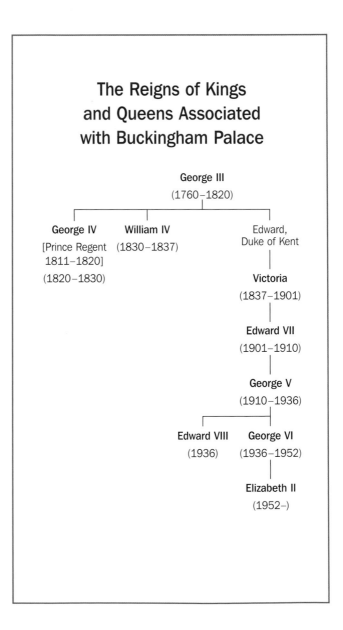

The Reigns of Kings and Queens Associated with Buckingham Palace

George III
(1760–1820)

George IV
[Prince Regent 1811–1820]
(1820–1830)

William IV
(1830–1837)

Edward, Duke of Kent

Victoria
(1837–1901)

Edward VII
(1901–1910)

George V
(1910–1936)

Edward VIII
(1936)

George VI
(1936–1952)

Elizabeth II
(1952–)

Introduction

Anyone visiting the State Rooms of Buckingham Palace for the first time cannot fail to be struck by the profusion, variety and richness of the works of art on view. This book has two purposes: to provide the visitor with a brief framework within which the Palace's collections may be appreciated and to give more detailed commentary on one hundred of the finest or most interesting items on show to the public.

To begin with, it is best to establish the succession of monarchs with whom the Palace has been associated: the Hanoverians up to William IV and the Saxe-Coburg/Windsors since then. It will become apparent that some of these monarchs were more involved than others as far as the acquisition of works of art was concerned. Above all, Buckingham Palace may be seen as both a tribute to and a legacy of George IV, though the figures of Queen Victoria and George III also frequently appear.

In essence the history of the Palace is as follows. George III bought Buckingham House, as it was then known, as a private residence for himself and Queen Charlotte in 1761. The house was then a fraction of the Palace's present size. The Hanoverian Court fulfilled its duties and functions nearby at St James's Palace. Their eldest son, the future George IV, set up his own private home, Carlton House, close by on Pall Mall in 1783.

WILLIAM BEECHEY, *Queen Charlotte*

As Prince of Wales and as Prince Regent, he obsessively expanded and altered both the building and its furnishings. By the time he became King in 1820 Carlton House was obviously too small, so he decided to transform Buckingham House from a private royal residence into a substantial royal palace where many of the ceremonial aspects of Court life might also be accommodated. Carlton House was demolished and the site sold to raise money.

George IV died before work on the new Palace was finished. His successor, William IV, completed the alterations but never lived here. Queen Victoria was the first monarch to use Buckingham Palace as her primary London residence and as the centre of her Court. She further enlarged George IV's buildings to accommodate a growing family and meet an increased need for administrative space. Most importantly as far as the appearance of the Palace is concerned, she closed off the open, three-sided quadrangle designed by George IV's architect John Nash by adding a new east front. She and her husband, Prince Albert, also made a number of changes to the interior decoration. After Prince Albert died in 1861 she effectively abandoned the Palace and it more

JOHN HOPPNER, *George, Prince of Wales*

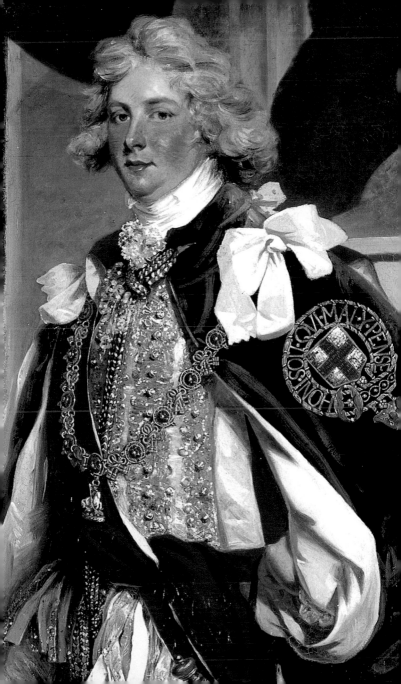

Franz Xaver Winterhalter,
Queen Victoria and Prince Albert

or less closed down. When her son, King Edward VII, succeeded to the throne in 1901 he found that little had changed since his father's day and he carried out an extensive programme of interior decoration. His successor, King George V, had the main façade refaced in 1913. Relatively little has changed since then.

As a collector George IV was a restless, voracious perfectionist. Over a third of the paintings and objects included in this book were first acquired by him for Carlton House. Not only did he continue to collect right up to the end of his life, he was also continuously rearranging what he had already acquired. In so doing he ran up staggering debts, much to the fury of his creditors and critics. One is entitled to ask where he found the inspiration for such lavish expenditure. Certainly not from his father George III, whose tastes were sober and judicious and who disliked ostentation. In any case, George IV was never on close terms with his father. His mother, Queen Charlotte, enjoyed collecting though she indulged her taste on a modest scale. More important were the examples of his forebears: his grandfather, Frederick,

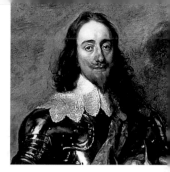

ANTHONY VAN DYCK, *Charles I*

Prince of Wales (not to be confused with George IV's brother, Frederick, Duke of York), the first significant collector among the Hanoverians; and, more distantly, the Stuart king Charles I, the greatest royal collector of all.

For George IV, as for Frederick and Charles before him, patronage of the arts was a pre-eminent duty of a prince or king. The ruler was to be judged by the magnificence of his residences and the splendour of his collections. A monarch's duties, to be sure, are complex and manifold. If George IV failed in most of the others, at least he succeeded spectacularly in this one.

Notes for the Visitor

The commentaries on the works of art in this guide are designed to follow the visitor route through the State Rooms. Within each room the objects are viewed in an anticlockwise direction. The name of the room is given at the foot of each page of text, with an arrow ➤ indicating when the last object in a room has been reached.

As the State Rooms are regularly used for entertaining and public ceremonies, individual objects may occasionally be relocated or removed.

The dates given for individual objects in the Royal Collection are adjusted from time to time to take into account the most recent research.

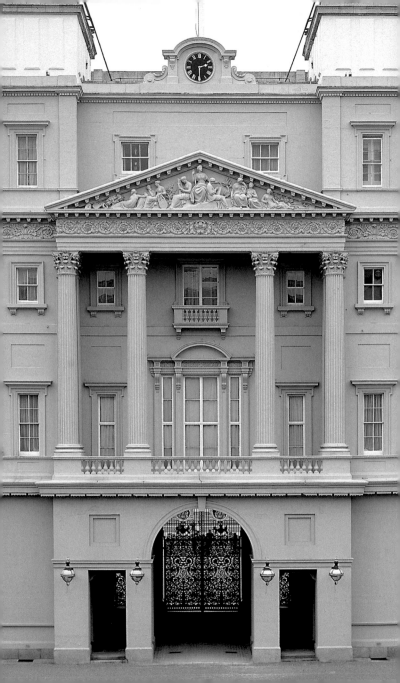

Pediment Relief of the Nine Muses
Edward Hodges Baily
1828

It is here in the Quadrangle that one can see what remains of the original façade designed by John Nash for George IV. Three projecting triangular porches supported by richly carved columns provided the focus for Nash's scheme. For their outward faces, or pediments, the sculptor E.H. Baily was commissioned to provide marble reliefs. The subject chosen for the central pediment (still above the entrance) was Britannia Acclaimed by Neptune, an allegorical way of celebrating the nation's recent naval victories over Napoleonic France and the rise of Britain as the centre of a global, maritime empire. To either side, at the end of the wings, the pediment sculptures represented the arts and sciences. The latter has disappeared. The former depicts the nine Muses, classical goddesses of creative inspiration. This pediment was relocated opposite the central one when Queen Victoria had the east front built.

By positioning these reliefs so prominently and publicly George IV was seeking to create a palace that might stand as an architectural symbol for the whole nation. Somewhat ironically, however, Nash's principal sources of inspiration came from the former royal and Napoleonic palaces he had admired in France.

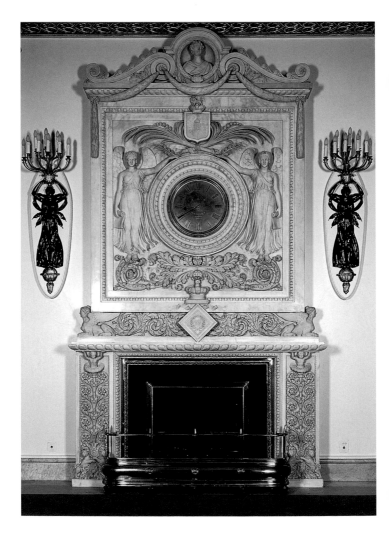

THE GRAND HALL

Marble Chimneypiece
Joseph Theakstone
1829

Before King Edward VII had the Grand Hall uniformly coated in white and gold in 1902, the walls had originally been painted in brightly coloured imitation marble, a decorative technique known as scagliola which Nash used throughout the Palace. As a result the subtleties of Joseph Theakstone's carving on this white marble chimneypiece would have stood out to greater effect than they do now.

This chimneypiece is unadorned with any colouring or gilding, and it is Theakstone's skills as a craftsman that make it an outstanding example of the carver's art. Colour would detract from the crisp detail of figures, flowers and animals. At the very top Theakstone included a small bust of George IV and elsewhere the monarch's crown, crest and monogram: understated tributes to the King who was responsible for the transformation of the original Buckingham House into the Palace it remains today.

In fact the architectural history of the Palace is nowhere more evident than here. The low ceiling, ingeniously relieved by Nash's idea of sinking the floor to create more space, reveals the proportions of the old house: the diminutive shell around which the present Palace was constructed.

Balustrade
Samuel Parker

1828–30

This superb balustrade was one of the most lavish and
expensive pieces of adornment by which George IV and his
architect John Nash determined to transform Buckingham
House into a palace. It was made by the craftsman Samuel
Parker and cost what was then the astronomical sum of
£3,900. Neither George IV nor Nash was in the least inclined
to control the amount of money spent on their new Palace.
The total costs they incurred were more than three times
the amount originally allocated by Parliament. Even then the
Palace was not entirely finished.

The balustrade is made up of huge sections of intricately
patterned cast and gilded bronze. The choice of motifs –
acanthus leaf, oak leaf, acorn and laurel – makes reference to
the opulence of ancient Roman decoration and one suspects
that even the most flamboyant of classical emperors would
have enjoyed sliding his decadent hand along its glittering,
sinuous richness.

But it is not simply the detail that impresses. The sweeping
undulations of its lines, particularly when viewed from the half-
landing, emphasise the contrast between the comparative
darkness and plainness of the ground-floor entrance and the
light, the gold and the sense of rhythmic movement of the
Grand Staircase.

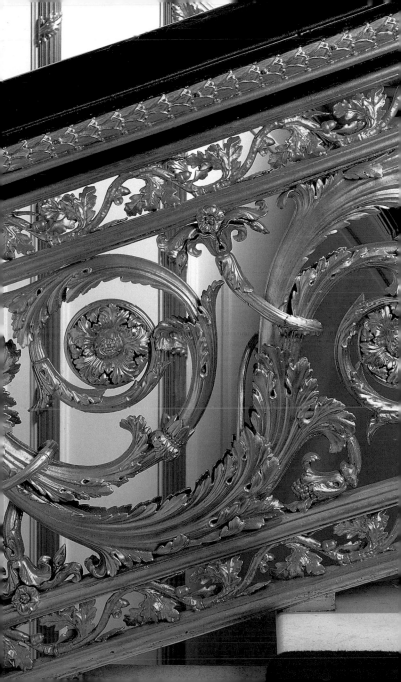

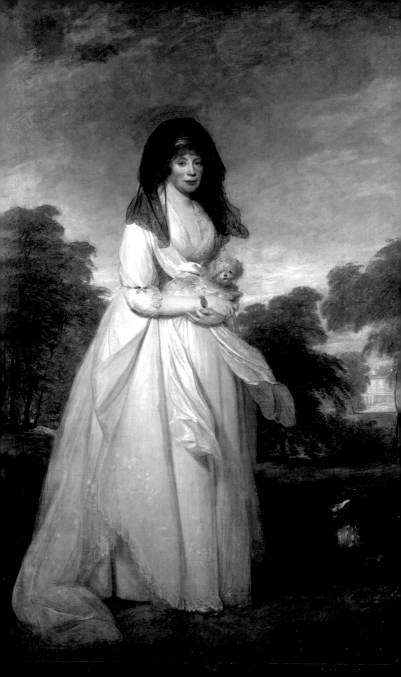

Queen Charlotte
William Beechey
1796

Queen Charlotte would probably have been surprised to find her portrait placed in so prominent and imposing a setting. She herself made no claims to beauty, admitting that an early fall from a carriage, which resulted in a broken nose, had much improved her appearance. In any case the portrait was originally painted to hang in the more domestic surroundings of the royal residence at Kew. The Queen is depicted without formality; she is shown in the grounds of her own rural retreat, Frogmore House near Windsor Castle, with three pet dogs. She wears neither crown nor ceremonial robes. No courtier attends her.

She is dressed with elegant simplicity; the lines of her dress are echoed by the delicate tracery of the autumnal trees behind. At the same time her expression perhaps betrays anxiety, as her hand plays nervously with the miniature portrait of her husband on her wrist. The King's illness had placed an enormous strain upon her in recent years.

It was Queen Victoria who had the portrait moved to Buckingham Palace. Queen Charlotte was her grandmother, and Queen Victoria was keen to celebrate both her family's pedigree and her own accession to the British throne.

George III
William Beechey

1799–1800

Beechey's portrait of George III was originally hung with its pair, the portrait of Queen Charlotte (see p. 21), at Kew before Queen Victoria moved them both to the Grand Staircase at Buckingham Palace, where they still hang side by side.

The King has been painted in the uniform of a General Officer with his horse and groom behind him and a squadron of cavalry in the background. The contrast with Queen Charlotte is clear – the King is shown as a man of action, while his consort plays a more passive, supporting role. Both the King and the Queen admired Sir William Beechey's work because he was able to lend a discreet note of informality to his sitters without sacrificing the deference due to rank and status. None the less Beechey's success did not save him from one of the King's periodic outbursts of temper; so violent was it that the artist wisely fell in a faint upon a nearby sofa. The King's son, the future George IV, found the episode outrageously funny and, it is said, nearly split his sides laughing.

More poignantly, this was the last portrait made of George III before his permanent withdrawal to Windsor and the final onset of insanity.

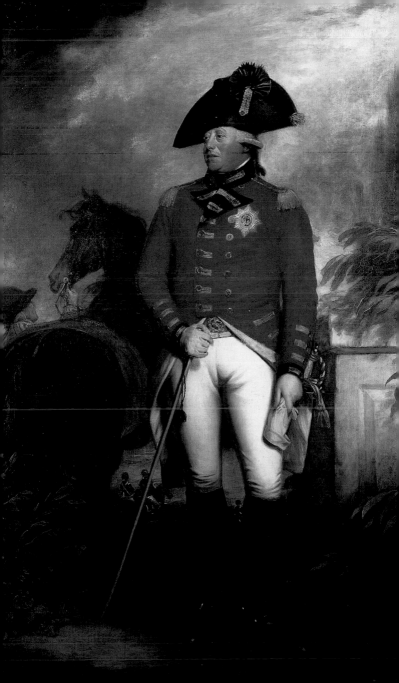

Augustus, Duke of Sussex
David Wilkie

1833

Augustus, Duke of Sussex, was Earl of Inverness and the sixth son of George III. He is shown here in Highland dress with the ribband of the Garter around his leg hose, leaning on a Highland broadsword and holding a chieftain's bonnet. Queen Victoria described him as her favourite uncle whilst she was young and he was included in the group of portraits on the Grand Staircase, chosen to show her immediate ancestry and her right to the throne.

The Duke's deerhound gazes adoringly at his master, who looks into the distance; the bond between them is clearly strong. The artist's broad brushstrokes and his use of light and shadow create a particularly atmospheric work using the standard full-length portrait format. The painting is signed and dated 1833 and it was critically acclaimed at the Royal Academy exhibition that year, where 'it seemed to lighten all around'. Scottish by birth and training, Wilkie succeeded Sir Thomas Lawrence as Principal Painter to George IV in 1830.

K.B.

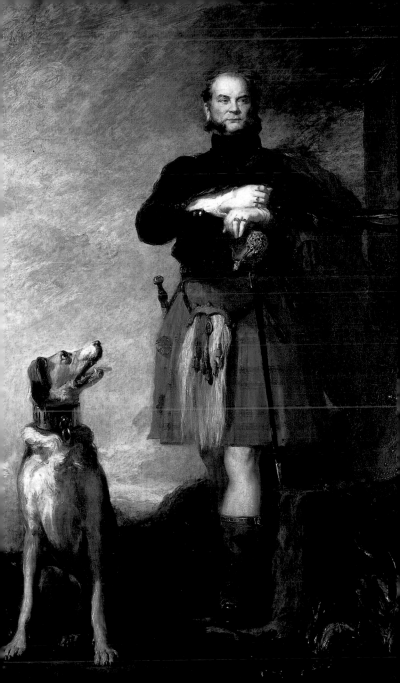

Cupids
Thomas Stothard
and Francis Bernasconi
completed 1830

In the recessed lunettes beneath the domed glass ceiling
are four refreshingly playful sculptures of Cupids. They were
designed by Thomas Stothard and modelled by Francis
Bernasconi at a cost of £500. This group faces the top of the
Grand Staircase, above the portrait of George III (see p. 22)
looking across at his Queen.

Surrounded by giant snowdrops, curling acanthus leaves
and doves, the Cupids appear to be constructing a nest for
themselves. They add a disarmingly light-hearted note to the
grandeur of the space, and to Queen Victoria's more solemn,
dynastic arrangement of portraits below. George IV evidently
much enjoyed them and complimented Thomas Stothard,
then over 70 years old, on the 'sprightliness' of his design.

Under King Edward VII the polychrome colour scheme
introduced by Queen Victoria and Prince Albert was covered
with white paint and gilding, a move deliberately intended to
introduce a fashionable and up-to-date French feel to the space.

THE GUARD ROOM

Prince Albert
Emil Wolff
1846

Facing the statue of Queen Victoria in the opposite niche of the Guard Room stands a sculpture of Prince Albert in Grecian military costume.

Though executed by different sculptors, the two works deliberately complement one another. Queen Victoria and Prince Albert face each other in mirrored poses with one leg bent and extended slightly forward. Even the shapes of the objects they hold are similar. Significantly, the Queen is not shown as the weaker sex; her pose is no less dynamic than that of the Prince, and he has no crown. Both have the emblems of the kingdoms of Ireland, Scotland and England (shamrock, thistle and rose) carved on their clothing.

The original sculpture (of which this is a later version) was given by Prince Albert to Queen Victoria as a birthday present in 1842, two years after they were married. It remains part of the Royal Collection at Osborne House, on the Isle of Wight. It differs slightly in that the Prince is shown without sandals and in a shorter tunic. He evidently felt somewhat underdressed for so public a setting, so a more decorous copy was made that exposes less of his leg and covers his feet.

Queen Victoria
John Gibson
1847

Dressed in flowing, classical robes and wearing a crown, the Queen appears here in the guise of an empress. She is holding out a laurel wreath in one hand and clutching a scroll in the other. The wreath is a badge of victory, the scroll evidently represents Law. According to the sculptor himself, she is represented as 'presiding over the affairs of the nation'.

Tiny traces of pigment have been found on the statue, indicating that it was originally partially tinted. By the time this sculpture was made – the Queen placed it here in the Guard Room in 1847 – it was well known that classical Greek sculpture had been coloured. Queen Victoria's husband, Prince Albert, was a keen antiquarian and would have approved of Gibson's decision to follow that tradition. Certainly the Queen later acknowledged her deference to his taste in all artistic matters. The style of the work is therefore appropriate for the sophisticated classical architecture of its setting. In real life the couple loved dressing up and held a series of lavish costume balls at Buckingham Palace in the 1840s and 1850s.

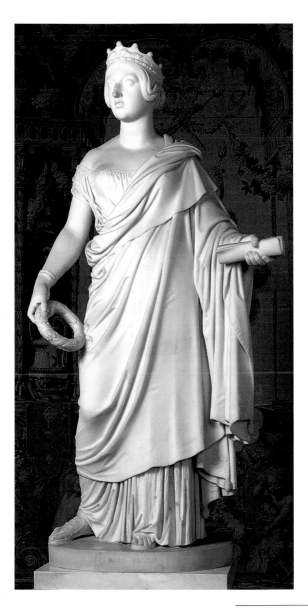

THE GUARD ROOM ➤

Lion Armchair
Morel and Seddon
1828

This is one of a set of chairs and sofas made for Windsor Castle in 1828. They were commissioned by George IV from the English furniture-making partnership of Nicholas Morel and George Seddon. With his former partner Robert Hughes, Morel had undertaken a large amount of work for the King when Prince of Wales and Prince Regent.

The chair is of carved mahogany which has then been gilded. The design is derived from furniture made for Napoleon a few years earlier by the Parisian cabinet-maker Jacob-Desmalter. Such furniture was made in a conscious attempt to re-create classical Roman forms and decoration. Napoleon deliberately sought to associate Empire France with the might and grandeur of imperial Rome. That such an overtly French style was used by Morel and Seddon for the furnishing of Windsor Castle is not surprising, given that Jacob-Desmalter helped them to design many of their pieces.

The entire suite is huge and numbers fifty-six separate items; this armchair alone is one of sixteen. It soon became evident that the King had over-ordered and that there was not room to accommodate all the pieces. Subsequently many pieces were used to furnish Buckingham Palace.

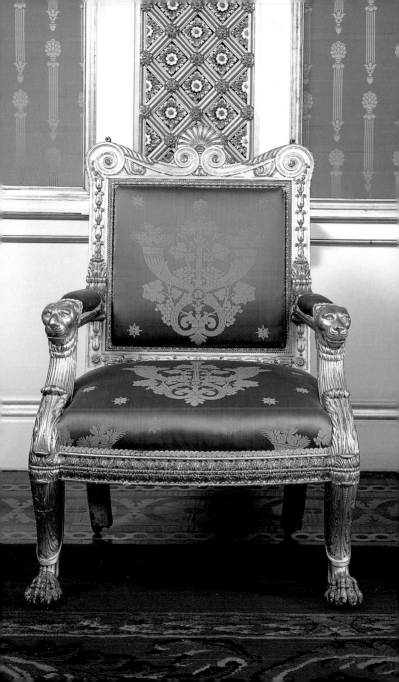

'Weeping Women' Candelabrum
Benjamin Vulliamy
1811

Twenty-one separate craftsmen were involved in the making of this candelabrum and its pair. The names of all of them survive in the Vulliamy account books.

The three weeping women are made of patinated bronze and they stand on a plinth of black marble. As they hide their faces in their hands, four brightly gilt bronze arms for lighting rise out above them. The piece and its pair are signed and dated along the top of the pedestal. They were made for George IV's use at Carlton House.

Many of the details derive from ancient Greek and Roman art: the stooped poses of the women, the flowers and skulls on the pedestal, the acanthus forms of the light branches. Nineteenth-century designers had access to engraved reproductions or drawings of all kinds of ancient, classical motifs and they regularly adapted them for fashionable, expensive items such as these.

Benjamin Vulliamy was one of a family of clockmakers, Swiss by origin, who served the monarchy for over a hundred years. They were also metal-smiths and Vulliamy designed and made other types of decorative furnishings, such as these candelabra. The family had a shop in Pall Mall, very close to Carlton House.

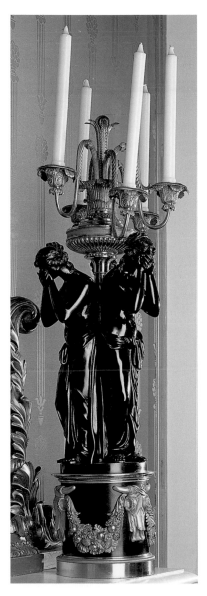

THE GREEN DRAWING ROOM

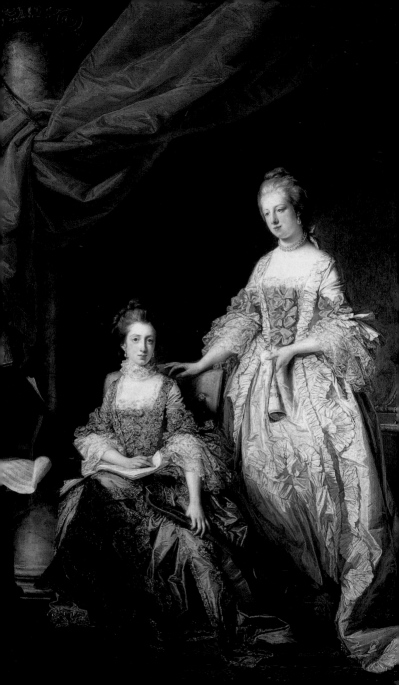

Princess Louisa Ann
and Princess Caroline Matilda
Francis Cotes
1767

This portrait of George III's two younger sisters was probably painted for their mother, Augusta, Princess of Wales, to hang in her house in Pall Mall. The girls are shown in informal poses. The room is imaginary, the massive red curtain adding a theatrical note to the composition. The substantial Ionic column with its scrolled capital is a traditional way of indicating learning. The sisters display their musical gifts. Princess Louisa is seated at a table with a music stand holding a gittern, a type of English guitar. Behind her stands Princess Caroline holding a roll of music.

Caroline had a wretched life. The year before the portrait was made, at the age of 15, she was married to the diseased King Christian VII of Denmark. Physically repulsed by him when she went to live in Denmark, she embarked on an affair with her doctor, Struensee. When it was discovered, she was condemned for adultery, separated from her children and banished to a fortress after being forced to watch her lover's execution. George III pleaded for clemency and she was allowed to go into exile in Hanover, where she died in 1775 at the age of 24.

Cabinet
with Pietra Dura Panels
Adam Weisweiler
c.1780 (with early seventeenth-century panels)

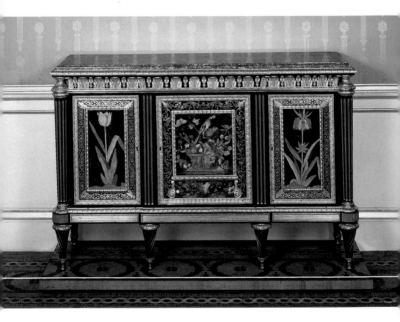

George IV's aim to turn the exterior of Buckingham Palace
into a national monument in celebration of Britain's defeat of
Napoleonic France did not prevent him from avidly collecting
sumptuous French furniture to fill its interior.

His passion for French furniture began long before the
outbreak of war with Napoleon, when he was living in Carlton
House as Prince of Wales. His fondness for all things French

may in part have been motivated – at least in his early years – by his wish to antagonise his father, George III. George III's political sympathies were with the Tories. The future George IV allied himself with their political opponents, the Whigs, whose tastes were strongly francophile.

This late eighteenth-century cabinet was probably bought to decorate Carlton House while he was still Prince of Wales. Its elegant style contrasts with that of the more ornate French pieces which he was to collect later. It is stamped by Adam Weisweiler, one of the leading cabinet-makers of the period. Here Weisweiler has incorporated seventeenth-century Italian pietra dura panels into an ebony-veneered cabinet, which is further adorned with Boulle marquetry of brass, pewter and tortoiseshell. George IV probably bought the cabinet around 1791; by 1792 his debts amounted to £400,000.

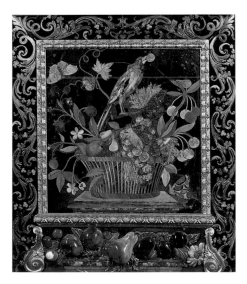

Richard Colley Wellesley
Martin Archer Shee

c.1832

Richard Wellesley, Marquess Wellesley, was the elder brother of the first Duke of Wellington. He commissioned this portrait himself when he was Lord Steward of the Royal Household, and requested permission to present it to the King, William IV, when he gave up the office. The Lord Steward occupied an eminent and powerful position. He was responsible for all officers and staff below stairs and for provisions within the Palace. The white staff which the Marquess holds is a symbol of office. Behind him rise the towers of Westminster Abbey. Yet one senses that the slightly nervous expression on his face does not quite fit the gravity of his dress or the grandeur of the imagined space that he inhabits. According to the painter Thomas Lawrence, Wellesley not only wore lipstick when he once sat for a portrait but had also squandered his fortune on women.

Shee was president of the Royal Academy and much favoured by the Marquess. Following this gift Shee then made successful portraits of William IV and Queen Adelaide. Later, however, Queen Adelaide referred to him as 'that tiresome Sir M. Shee' and went on to describe a portrait of her by him as 'monstrous'.

Pot-pourri Vase
Sèvres
1758

This is one of the finest pieces of Sèvres porcelain in the Royal Collection. George IV bought it in 1817.

The Sèvres factory was founded in 1738 and was quickly bought by Louis XV, King of France, who held exclusive sales once a year at Versailles. Sèvres was close to the home of Louis XV's mistress, the capable, cultured and extremely powerful Madame de Pompadour, and this vase may have been part of her collection.

This piece admirably displays the technical virtuosity and superb quality for which the Sèvres factory is famed. It is made of soft-paste porcelain – Europe's attempt to imitate Oriental hard-paste porcelain. Soft-paste porcelain was notoriously difficult to model and vulnerable to warping when fired. Given the complexity of this vase's boat-shaped form and the number of times that it would have had to be fired to achieve the elaborate glazes and gilding, its technical brilliance is all the more astonishing. Soft-paste porcelain was not only difficult to work, it also took a terrible toll on the health of the craftsmen who worked with it and three in four are said to have died from respiratory illnesses.

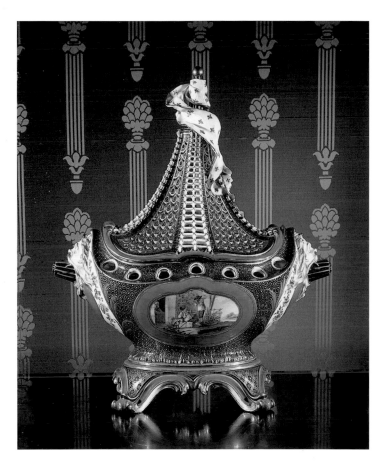

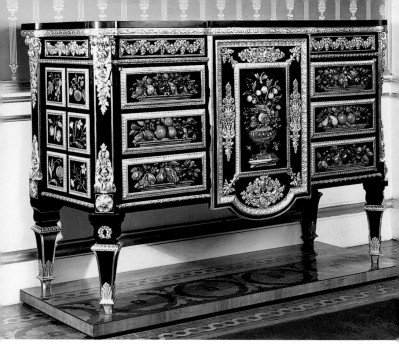

Chest of Drawers with Pietra Dura Plaques
Martin Carlin
c.1775

On this piece, some of the pietra dura (literally 'hard stone')
panels date from the seventeenth century. The Parisian
cabinet-maker Martin Carlin reused them for this cabinet in
the late eighteenth century. The hardstones are naturalistically
carved in high relief to represent fruit, birds and insects. The
panels were made by an Italian craftsman, G.-A. Giachetti,

in the French royal workshops and were probably once set
into an elaborate cabinet of baroque design. In contrast, the
hardstones in the Florentine panels on the cabinet by Adam
Weisweiler, also in this room (see pp. 38–9), have been inlaid
into black marble to create flat pictures.

This cabinet belonged to a renowned French singer and
chorus girl called Marie-Joséphine Laguerre who supplemented
her income from the Paris Opera by demanding outrageously
expensive gifts from an unending stream of wealthy lovers.
She died in 1782 at the age of 28, exhausted by excess
of every kind.

After the Revolution of 1789, the French royal collection
and many other aristocratic collections were broken up. Many
superb pieces were released onto the market and bought
by George IV. The King managed to buy this piece in 1828
through the offices of his French pastry cook, François Benois.

Mahogany and Gilt Door

1820s

It is worth stopping to look more closely at one of the sets of doors – first, because one realises how much reflected light, and an increased sense of space, their mirrored panels contribute; second, because one can appreciate here in miniature one example of the craftsmanship, expense and attention to decorative detail that is to be seen throughout the Palace.

Most, if not all, of the doors in the State Rooms of Buckingham Palace were designed by George IV's architect, John Nash. The gilt decoration was provided by Samuel Parker, who also constructed the balustrade for the Grand Staircase (pp. 18–19).

Each is made up of a huge pair of folding, mirrored doors, 360cm (12 feet) in height, using Spanish mahogany mounted with gilt bronze and filled with long panels of mirror glass. Above each glass panel there is a mahogany panel decorated with the royal crown and the rays of the Garter star (see p. 137). The outer borders are decorated with innumerable gilt bronze fleurs-de-lis – each one was cast and attached separately at a cost, per item, of 7 old pence.

THE THRONE ROOM

Oath of the Horatii Clock
Claude Galle
c.1800

Bought by George IV in 1809 while still Prince of Wales, this
clock first adorned Carlton House. Its composition follows
closely a famous painting of the same title of 1784 by Jacques-
Louis David, now in the Louvre. The story is from ancient
Roman history. The three Horatii brothers face their father,
who holds out arms for them, having taken an oath of fidelity

to fight the Curiatii for the
glory of Rome. The brothers
eventually defeated their
enemies but two of them
were killed. This part of the
story is shown on the green
marble base. The surviving
brother greets his father in
the centre. To the left the
other two are shown dying
of their wounds, to the right
their sister wrings her hands
in shame and grief because
she was betrothed to one
of her family's enemies.

David's painting was commissioned for the French royal
family while he was in Rome; the story was chosen to highlight
the virtues of loyalty and self-sacrifice. Later, though, the artist
devoted himself to the cause of the Revolution, and used his
talents in support of the Republican cause.

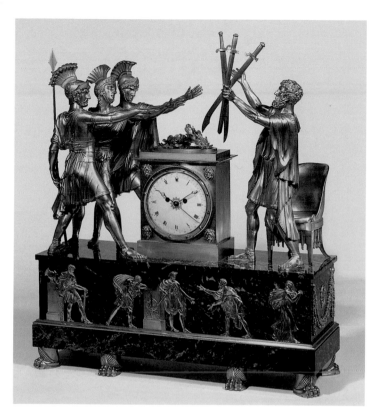

Proscenium
Francis Bernasconi

completed by 1830

The word 'proscenium' refers literally to the space between the stage and the auditorium in a theatre. The official functions of the king or queen of course also contain much that is theatrical, and here in the Throne Room George IV's architect John Nash decided to set the throne apart from the rest of the room where courtiers or commoners congregate. Nash had designed theatres, including the Theatre Royal, Haymarket, before his appointment as archiect to George IV.

The winged figures looking out at either side were modelled in plaster to Nash's design by Francis Bernasconi, and have been variously described as genii or winged Victories; both are classical in origin and are found, for example, on Roman triumphal arches. They are holding double, looping swags from which hang medallions decorated with the cipher of George IV.

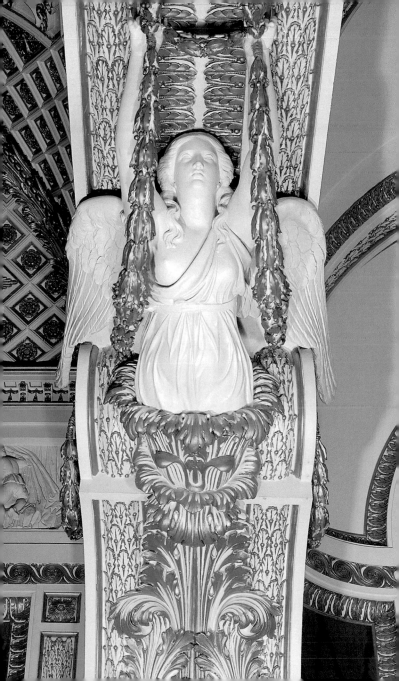

Council Chair
Tatham and Co.
1812

By late 1810, George III's mental condition had deteriorated
so much that he was declared insane. Early in 1811 the
Regency Act was passed and the Prince of Wales became the
Prince Regent, responsible for the King's duties and functions.
His new title has since been used to describe a distinct period
in the history of English design: Regency.

The following year, 1812, the Regent had a pair of Council
Chairs made for his new Throne Room at Carlton House.
The chairs were made from carved and gilded lime, pine
and beech, and their design is quite startling. Two crouching
sphinxes, mythical creatures of inscrutable wisdom, form the
arm rests with their wings. Their tails curl round to form part of
the pattern on the back of the chair. The shape and decoration
of the chair are based on ancient Roman thrones, known at
the time through recently published engravings. The imagery is
therefore – appropriately for a regent – both wise and powerful.

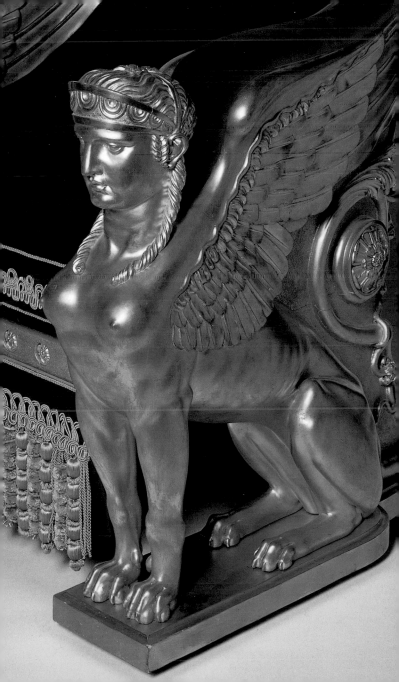

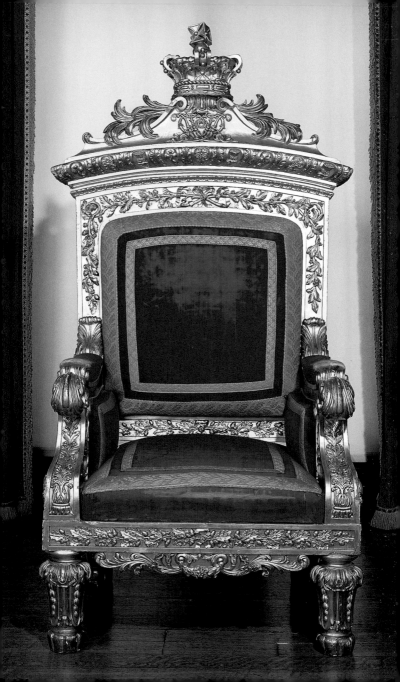

State Throne of Queen Victoria
Thomas Dowbiggin
1837

The throne is carved with leaves and scrolls, branches of oak, acorns and acanthus leaves. On the back are the rose, thistle and shamrock of the three kingdoms. It was supplied together with the canopy (now altered) in 1837 by the London cabinet-maker Thomas Dowbiggin at a cost of £1,187.

The 18-year-old Queen was only 150cm (4ft 11in.) tall and must have been somewhat overwhelmed by the large proportions of this throne. However, contemporaries commented on the young Queen's extraordinary presence. 'She not only filled the chair, she filled the room,' said the Duke of Wellington after meeting the new Queen for the first time.

During the reign of Queen Victoria the throne would have been placed on the dais underneath the canopy where Queen Elizabeth II and the Duke of Edinburgh's thrones now stand. This pair of thrones and those of King George VI and Queen Elizabeth, which are also in this room, were used at the coronation ceremonies of these monarchs in Westminster Abbey.

Archers
Thomas Stothard and E.H. Baily
1828

Running around the whole room is a spectacular frieze presenting Tudor history in the guise of ancient Greek sculpture. The frieze, designed by Thomas Stothard (see p. 26) and executed by E.H. Baily (see p. 15), depicts scenes from the Wars of the Roses, a stupendous fifteenth-century dynastic struggle. Above the proscenium is the Battle of Tewkesbury; facing the windows is the Battle of Bosworth Field. Above the windows comes the resolution: the marriage of Henry VII to Elizabeth of York. Above the door appears the classical goddess of war and destruction, Bellona; with a torch in each hand and flanked on either side by archers, she presides over the dead and dying.

The frieze is shallowly modelled. The archers illustrated here have been raised in scaled proportion; this creates the illusion that they are receding into space, while allowing the figures to keep their elegantly ordered symmetry. The style and the technique have been borrowed from ancient Greek sculpture. Shortly before Baily carved this frieze, the fifth-century BC Parthenon frieze from Athens (part of the Elgin Marbles) had arrived in England. It was held up as the summit of human artistic achievement and provided inspiration for countless nineteenth-century artists and sculptors.

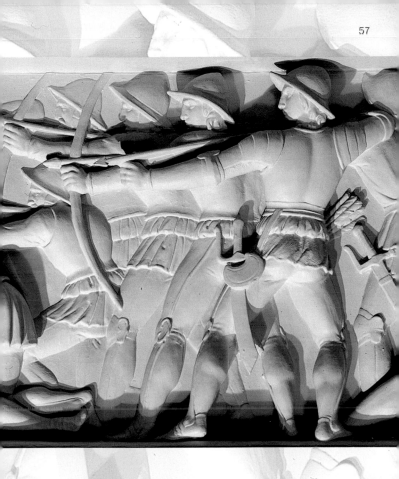

THE THRONE ROOM ➤

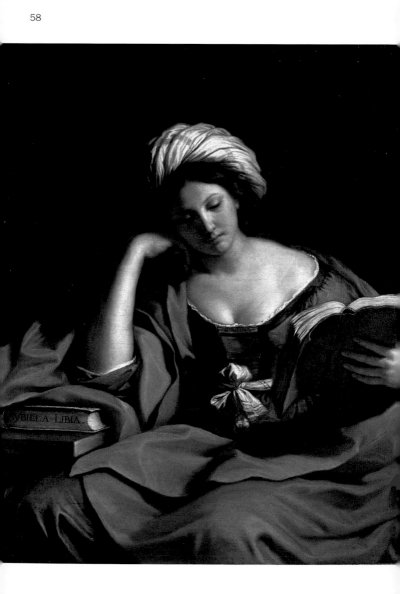

The Libyan Sibyl
Guercino
c.1651

Though Buckingham Palace owes most of its contents to
George IV, this painting was bought by George III through his
Librarian, Richard Dalton. Dalton acquired it in Italy in 1762
while Buckingham House was being fitted out for the King and
Queen. George III hung it first at Buckingham House, and later
at Windsor Castle.

It is by the seventeenth-century Italian artist Guercino –
a nickname referring to the artist's squint. His real name was
Giovanni Francesco Barbieri and he was based in Bologna,
though he also worked in Rome. The painting represents
a Sibyl. Sibyls were ancient oracles or prophetesses from
different parts of the ancient world. This one is the Libyan
Sibyl (the closed book is inscribed *SYBILLA LIBIA*); there
was another famous oracle at Delphi. Sibyls were capable
of foreseeing the future though often they expressed their
predictions in the form of enigmatic riddles. Here she is
seen, very relaxed, reading a book and patently undisturbed
by the burdens of divine revelation. She is dressed in
contemporary clothes.

Guercino's late style, of which this is an example, is
characterised by its soft colour and brushwork. An unrivalled
collection of his drawings is held at Windsor Castle. These,
too, form part of the Royal Collection.

Boulle Cabinet
Pierre Garnier
c.1770

André-Charles Boulle became Louis XIV's cabinet-maker at
the age of 30. He gave his name to a decorative technique
of metal and tortoiseshell marquetry. Although the technique
had first been used in Italy in the sixteenth century, it was
Boulle who perfected it and used it to great effect on late
seventeenth- and early eighteenth-century Court furniture.
A fretted pattern is cut from sheets of brass, tortoiseshell
and occasionally pewter sandwiched together. These fretted
sheets are then separated and rearranged to produce two
complementary images: a tortoiseshell background inlaid with
metal and a metal background inlaid with tortoiseshell. It is for
this reason that furniture decorated with Boulle marquetry very
often comes in pairs. The reverse pattern of this cabinet may
be seen on its pair, which stands on the other side of the
Picture Gallery doors.

The popularity of Boulle marquetry continued throughout
the eighteenth and nineteenth centuries. In these cabinets
the Boulle marquetry has been incorporated into a restrained
Neoclassical framework quite different from its Baroque
ancestors. This pair was bought by George IV through the
good offices of his pastry cook, François Benois, in 1819.
Benois was also noted for the excellence of his hot jellies.

The Stolen Kiss
David Teniers the Younger
c.1640

In contrast to the grand subject-matter and monumental style of Italian art, Dutch painters of the seventeenth century depicted scenes of ordinary life: landscapes, sea paintings, tavern scenes, domestic interiors. Teniers's picture, *The Stolen Kiss*, offers low-life comedy in a country farmhouse as a young man kisses a woman – the wife, or daughter perhaps, of the man descending the stairs. His anxious presence is pointed out by the child. In addition Teniers includes a number of finely observed still-life objects: a brass cauldron, a hanging hare, cheese, wine, fruit and vegetables. This act of amorous indiscretion is set within a display of agricultural bounty, all warmly bathed in golden light, which lends the incident an innocent, harmless charm.

Though George IV acquired most of the seventeenth-century Dutch paintings in the Royal Collection, his grandfather, Frederick, Prince of Wales, bought this particular example. Frederick's tastes were wide ranging. In addition to Dutch paintings, he collected Italian, Flemish and French works of art. He also had a Chinese barge made for his use, rowed by Chinese boatmen, and built the Chinese Octagon or 'House of Confucius' at Kew.

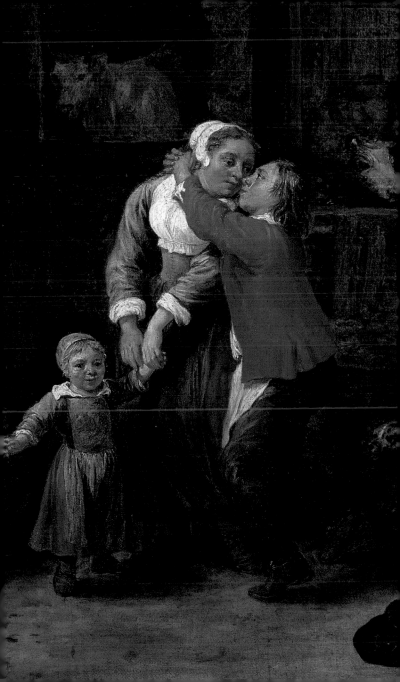

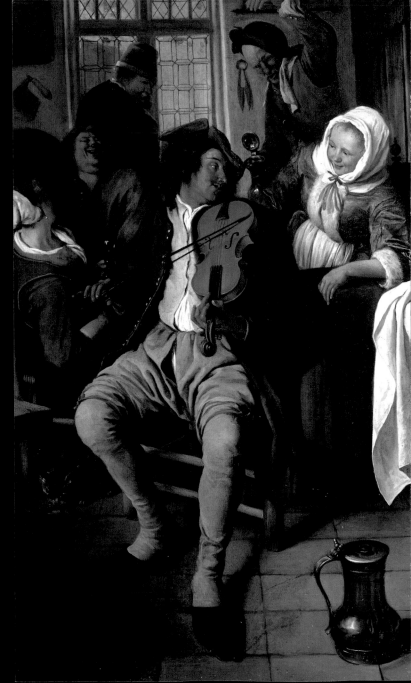

Interior of a Tavern with Cardplayers and a Violin Player
Jan Steen
c.1665

Jan Steen was the son of a Dutch brewer, and later in his life owned an inn. So it seems fair to assume that paintings such as this give a good description of the beery warmth and rowdiness inside a seventeenth-century Dutch tavern. At the same time it is a carefully organised image. The violinist is positioned at the top of a triangular composition. He has been distracted by a servant girl. To their left there is more flirtation between a well-built man throwing back his head to laugh (probably a self portrait) and the woman seated next to him. To the right a woman at a card table holds up the ace of diamonds as she looks out at us. Her dress, coiffure and proximity to a well-turned-out dog suggest that she is a prostitute. Alcohol and music, in other words, are preludes to amorous activity. Steen includes finely detailed still-life objects, including an earthenware ashbox to provide warmth.

The painting was bought in 1818 by George IV, who collected many of the finest Dutch and Flemish paintings in the Royal Collection. He intended to hang them all together in the Picture Gallery.

St Philip Baptising the Eunuch
Jan Both
c.1640

The real subject-matter of this painting is the luminous landscape bathed in wonderful golden light. The figures in the foreground are dominated by their surroundings – their human scale is exaggerated by their long shadows. Jan Both, the artist, spent some years in Italy, but he has created an ideal landscape that is not based on any particular place. This type of painting became popular in Holland, where the scenery is very different, and Both had a great influence on later Dutch landscape artists.

The scene is based on an incident recorded in the Acts of the Apostles in the New Testament. St Philip is shown baptising the treasurer of Queen Candace of Ethiopia on his return from Jerusalem. The treasurer's chariot can be seen further up the road, half-hidden by trees. A rider and a page, whose turban adds an exotic flourish, witness the scene.

The painting was purchased at auction by George IV when Prince of Wales, and hung in the Audience Room at Carlton House. Dutch seventeenth-century paintings were in fashion at this time and were often hung in lavish rooms decorated in the French eighteenth-century style.

K.B.

'The Music Lesson'
Jan Vermeer
1662–4

When this painting was bought by George III
in 1762 it was thought to be the work of
an artist called Frans van Mieris. In the
nineteenth century it was recognised as a
masterpiece by Vermeer, only thirty-four of
whose paintings are known to survive.

The composition has been constructed
with geometric precision. The rectangles of
the virginals, the mirror and the picture are
carefully balanced with the diagonals of the
floor tiles, the shadows on the far wall and
the folds of the Oriental carpet draped over
the table. Nothing violent or excessive
intrudes upon this interior; only the diffused
light falling from left to right, highlighting the
white jug and the buttons on the blue chair.

The Latin inscription on the lid of the
virginals translates 'Music is a companion in
pleasure, a remedy in sorrow.' Sorrow would
better suit the atmosphere. Vermeer may have
intended to draw an allusion between music
and love but the nature of the relationship
between the two figures remains enigmatic.
The woman has not returned the man's
intent gaze. Yet in the mirror her head is
inclined a little to the right. The feet of
Vermeer's easel may also be seen.

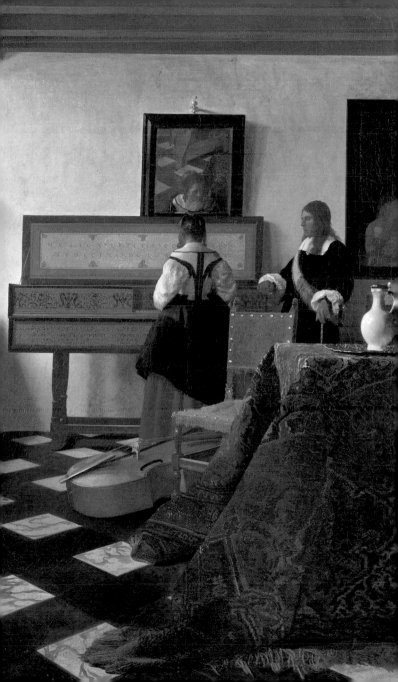

The Shipbuilder and his Wife
Rembrandt van Rijn
1633

In 1650 a Rembrandt portrait that had belonged to Charles I
was valued at just £4. In 1811 the Prince Regent bought
The Shipbuilder and his Wife for £5,250. It was the most
expensive painting he ever bought and, to mark this spectacular
purchase, it was displayed at a fête given that year at Carlton
House for the French royal family.

The picture is signed and dated 1633. Rembrandt had just
moved to Amsterdam and was at the height of his success.
Jan Rijcksen was a rich shipbuilder in Amsterdam. Rembrandt
has shown him sitting at his desk, working on a drawing while
his wife Griet has burst into his study to hand him a message.
The emphatic diagonals in Rembrandt's cleverly planned
design lend this domestically intimate moment both drama
and energy. Even the position of the arm of his chair and
the angle of his dividers seem to have been calculated to
complement her diagonal movement. The lighting emphasises
individual character: the wife's sense of urgency compared
to her husband's sturdy professionalism. As such, the portrait
also pays tribute to the couple's harmonious relationship
in which the man's creative powers are supported by the
woman's menial actions.

Japanese Lacquer Bowl with Gilt Bronze Mounts

eighteenth century

Lacquer is a tree resin, applied in numerous coats, usually over a wooden core. The technique goes back to the fourth or fifth century BC. Articles made from it were prized for their lustre and for their brilliant, deep colours and smooth surface. The lacquer here incorporates gold dust in imitation of a kind of spangled quartz known as aventurine.

Japanese lacquer was highly esteemed in Europe. George III and Queen Charlotte had a Japanese room at the original Buckingham House – it was one of the most expensively furnished of all. However, due to trading restrictions lacquer was an exotic rarity. It is likely that this bowl left Japan via Nagasaki in the early eighteenth century. Here the Dutch were allowed a small trading concession on an artificial island in the harbour; no other Western traders were allowed to enter Japan until 1853. Because the Lac tree could not be cultivated in Europe, Western craftsmen imitated lacquer using layers of coloured varnish in a technique called Japanning. The Western appetite for true lacquer was also fed by the Chinese, who began copying Japanese pieces and exporting them to Europe.

In the mid-eighteenth century this bowl – one of a pair – was embellished by the addition of gilt bronze mounts by a French craftsman. These include the face of a Bacchante or follower of Bacchus, the classical god of wine.

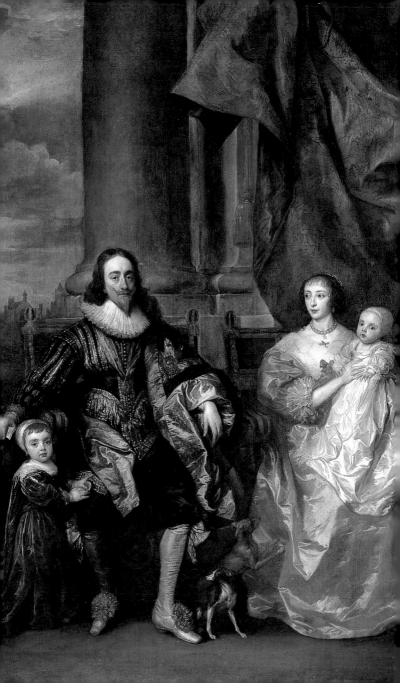

Charles I and Henrietta Maria
Anthony Van Dyck
1632

This was Van Dyck's first commission following his appointment as Court Painter to Charles I in 1632. It shows Charles and his Queen, Henrietta Maria of France, with their two eldest children: Prince Charles, later King Charles II, standing before his father and Princess Mary in her mother's arms. In the background we glimpse a silhouetted view of the Palace of Westminster, where Parliament was later to sentence Charles to death.

Nothing quite like it had been seen in England before and Charles hung it prominently in the Palace at Whitehall. What sets it apart is the apparently effortless way in which Van Dyck seemed able to combine the formal demands of official state portraiture with the informalities of family domesticity. Its size, the acres of shimmering silk and the grand classical column lend the image official gravity. Yet at the same time the King and Queen are seated, Charles has placed his crown on one side and two tiny dogs play between the royal couple.

The painting was sold after Charles I's execution but was recovered by his son, Charles II.

Venice: The Piazzetta
Canaletto
c.1727

The immaculate views that Antonio Canale –
or Canaletto – painted of his native Venice were
mostly bought by English visitors making the
Grand Tour. This view would have been the
first glimpsed by visitors on disembarking.
The Piazzetta leads directly to St Mark's Square,
the political and religious centre of the city. The
dominant building on the left is Venice's most
prestigious library, the Biblioteca Marciana; on
the right is the façade of the church of St Mark,
home to the relics of Venice's patron saint.

While Canaletto's reputation was founded on
the accuracy of his pictures, the truth is more
complex. Very often he subtly manipulated what
he saw for greater visual impact. Here he has
elongated the façade of St Mark's so that the
Piazzetta appears larger and grander.

This picture was made early in Canaletto's
career for Joseph Smith, the British Consul in
Venice, who introduced him to many aristocratic
clients. The free handling of the paint and
the arresting contrasts of light and shade are
characteristic of this period. Consul Smith built
up his own collection of Canaletto's works which
was bought by George III in 1762. With over
fifty paintings, numerous drawings and etchings,
it remains one of the greatest collections of
the artist's works.

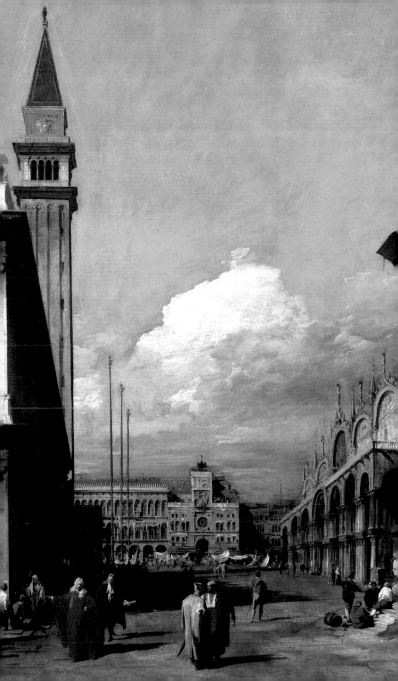

THE PICTURE GALLERY

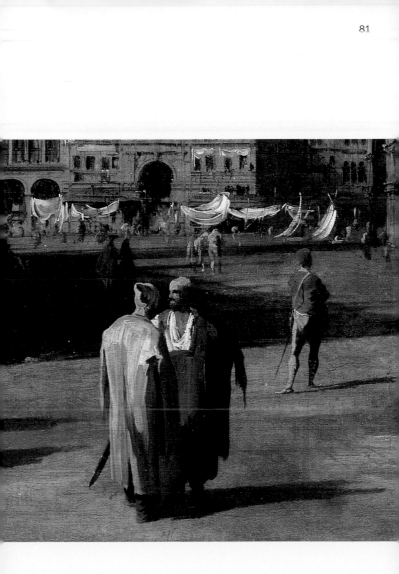

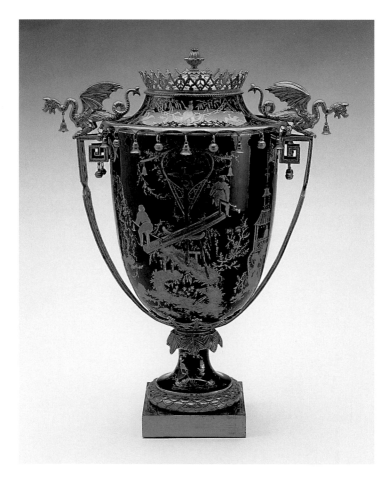

Pot-pourri Vase
Sèvres
c.1789–92

The decoration of this French vase (and its pair) is meant
to imitate black and gold lacquer from Japan and China.
True lacquer, which is made from the sap of the Lac tree,
was a highly valued exotic rarity and was often imitated in the
West. The vases are actually made from hard-paste porcelain,
which itself was a Chinese discovery. For hundreds of years
Europeans had attempted to discover the jealously guarded
secret of Oriental porcelain. Until this technique was
discovered in Dresden in the early eighteenth century,
European porcelain was usually a mixture of clay and ground
glass known as soft-paste porcelain. True hard-paste porcelain
is made from kaolin or china clay

The Chinese-style figures and scenes are applied in
platinum and two tones of gold. Platinum was introduced
at Sèvres around 1789 and at that date was a relatively
inexpensive metal. It was used instead of silver because it
does not tarnish, an especially important consideration when
the ground colour is black. Differing shades of gold, such as
those used here, were made by combining it with other metals
such as copper or silver.

The gilt bronze mounts are of exceptional quality and
complete the overall chinoiserie theme with their fantastic
dragons and miniature bells. The vases were purchased by
George IV in 1815 for Carlton House. However, in 1819
they were moved to the more appropriate setting of the
Royal Pavilion, Brighton.

M.W.

Jonah and the Whale
Gaspard Dughet
c.1653

The artist has chosen to depict the climactic moment when
the Old Testament prophet Jonah is thrown off the ship into
the sea by suspicious sailors and is swallowed by a whale.
A dramatic bolt of lightning strikes a castle at the very moment
that Jonah falls into the water. The artist has included a group
of shepherds in the foreground and their shocked reaction is
intended to mirror our own.

The painting is one of four by Gaspard Dughet in the Royal
Collection. All of them were probably purchased by Frederick,
Prince of Wales, who was a notable collector of French
painting. It was instantly popular with visitors, who enjoyed the
terror and horror of the scene. The whale, in particular, is very
inventive, with sharp teeth and huge mouth ready to swallow
the unfortunate prophet.

Dughet was the brother-in-law of the highly influential
French artist Nicolas Poussin. He spent most of his career in
Rome, painting idealised landscapes based on the countryside
around the city. This was his only sea-piece and it was copied
and engraved several times. K.B.

Landscape with St George and the Dragon
Peter Paul Rubens
1630

St George, dressed in armour and a red cloak, faces the Princess, also in red, whom he has just saved from a dragon.

Here, as befits the national patron saint of England, Rubens has lent the story a peculiarly English setting. Although the landscape is imaginary, recognisable buildings can be made out beyond the river: towards the left, Westminster Abbey (without the bell towers); further right, on the bend, Lambeth Palace. In addition St George and the Princess are said to be thinly veiled portraits of Charles I and his Queen, Henrietta Maria.

Charles I deeply admired Rubens's talents and tried in vain to persuade him to come and be his Court Painter. Rubens did however visit London in 1629–30, when this painting was most probably begun.

Two cherubs descend with laurel wreaths, emblems of victory. One of them holds a palm leaf, emblem of martyrdom and a reminder that St George would ultimately be beheaded. By uncanny coincidence, nearly twenty years after this picture was painted Charles suffered the same fate. After his execution the painting was sold but it was reacquired by George IV in 1814.

The Rape of Europa
Claude Lorrain
1667

In classical mythology Europa was a king's daughter. Jupiter fell in love with her and, disguising himself as a white bull, came to join her on the seashore where she played with her attendants. Charmed by the bull's good nature, she hung garlands of flowers over its horns and climbed onto its back. It carried her out to sea, to the island of Crete, where Jupiter resumed his normal shape and ravished her.

In the foreground the unsuspecting Europa is carried towards the shore. The group of figures form a decorative frieze whose pastel tones of lilac and blue complement those of the sea and sky, and it is easy to forget the traumatic events that are about to unfold. However, as with many of Claude's paintings, it is the surrounding landscape that is the true subject. The various elements and colours are balanced perfectly, so that the viewer is led along a rocky pathway from tree to tree and then out to sea to the fortress beyond. The landscape is lit by a pale golden early morning light that creates a shimmering effect on the water and in the sky above.

George IV bought this painting at auction in 1829.

K.B.

THE PICTURE GALLERY

Pedestal
Gilles Joubert
1762

This pedestal and its pair were made to support clocks, one solar and the other lunar, in the bedroom of King Louis XV at Versailles. They now support two bronze busts of the Roman Emperors Vespasian and Augustus. Beautifully bulbous swellings towards the base, with gilt bronze decoration over precisely wrought diamond parquetry, demonstrate the fanciful imagination and supreme technical skills of their maker.

The bronze work contains mythological references to Diana, goddess of the moon, with her bow and arrow and hunting horn (for the lunar clock); and on the other to Apollo, god of the sun, with his lyre (for the solar clock). When George IV bought them in 1827, they had been separated from the clocks. He would probably not have known what they had been used for.

These pedestals are good examples of the pioneering taste of George IV. Although he continued to buy modern furniture in the latest styles, he acquired many flamboyant pieces of mid-eighteenth-century French furniture in the curvaceous Louis XV style. Such furniture was relatively unfashionable and spurned by many collectors, but George IV was happy to mix it with pieces dating from the seventeenth, late eighteenth and early nineteenth centuries.

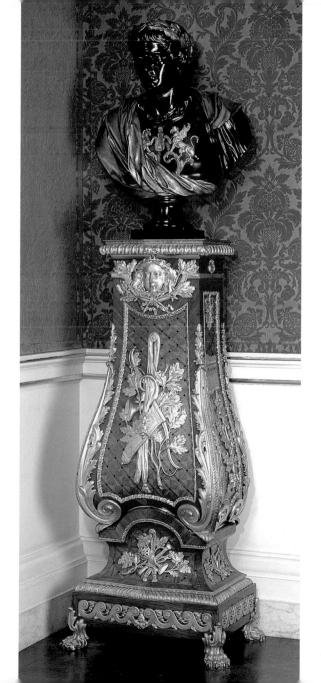

Landscape with a Negro Page
Aelbert Cuyp
c.1655

Cuyp's paintings were much sought after by British collectors of the eighteenth and nineteenth centuries. In fact, most of his paintings have ended up in Great Britain. They were admired for their meticulous detail, for their serenity and for their evenly worked surfaces – which the critic William Hazlitt compared at the time to 'the down of an unripe nectarine'. Above all Cuyp was acclaimed for his treatment of natural light. His fascination with it is clear: roughly half the painting is devoted to the sky, which bathes figures, animals and landscape in soft, silvery tones.

Many of the individual components of this painting appear in other works by the artist: both of the horses, the two dogs and the pageboy, for example. Cuyp's landscapes, in other words, do not describe specific events or moments but were constructed from a stock of motifs which he had observed and recorded at different times.

A number of his paintings, like this one, depict rural scenes with fashionably dressed figures accompanied by their horses and servants – elements that would naturally have appealed to aristocratic British collectors. This work was bought by George IV in 1810 to hang at Carlton House.

Charles I with Monsieur de St Antoine
Anthony Van Dyck
1633

Since ancient Roman times it has been conventional to assert a ruler's power and authority by showing him on horseback. As King Charles looks down on us, his riding master Monsieur de St Antoine looks up towards him, reinforcing the difference in rank and status. Even Charles's muscular horse obeys the King's commands without question as he rides impeccably with inward-turned foot and down-turned heel through an imaginary classical arch.

Van Dyck's design is dynamic: horse, rider and servant progress diagonally forwards and are counterbalanced by the twist of the horse's head and neck, and the position of the King's baton. Even the shield bearing the royal arms, propped up against the arch, stands at a jaunty diagonal angle.

Van Dyck's efforts were well rewarded: the painting was hung amongst illustrious Renaissance paintings of Roman emperors on horseback at St James's Palace. He himself was given a pension, a handsome house at Blackfriars, a gold medallion and a knighthood. Because it was such a forceful image of royal power the painting was sold after Charles's execution, but it was recovered by his son Charles II after the Restoration of the monarchy in 1660.

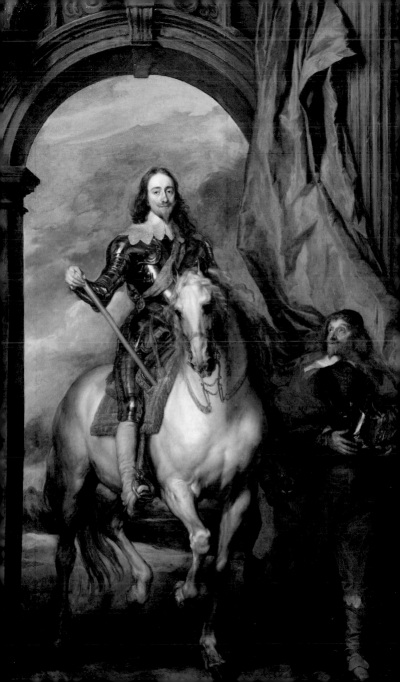

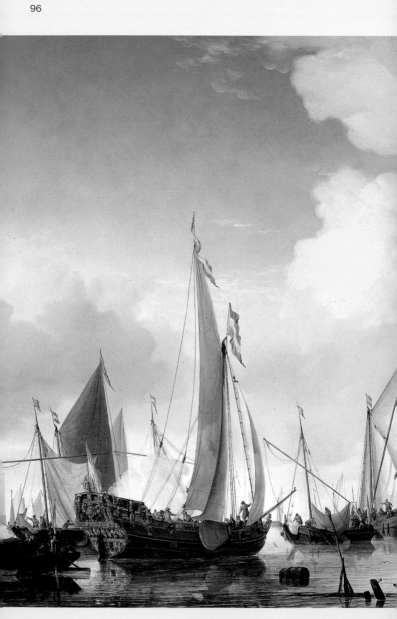

A Calm
Willem van de Velde
the Younger
c.1655

In the foreground an inexpensively dressed man, wading barefoot through the shallows, handles a child-sized canoe. His figure serves as a scale to all the ships and boats behind and provides a contrast in status to the grandly decked Dutch States yacht to the left, with its prominent orange flag and arms.

Years after it was painted, in 1672, Van de Velde and his father came to work in England. That year the English and Dutch fleets clashed off the coast of East Anglia, but the Van de Veldes went on to found the British school of maritime painting.

Seventeenth-century Holland was a newly founded, Protestant trading empire. It had no ruling monarchy or aristocracy to favour paintings of historical or mythical subjects. This kind of seventeenth-century seascape was immensely popular, though, with eighteenth- and nineteenth-century aristocratic English collectors. Such pictures appealed most of all for their mastery of intricate detail, their meticulous finish and their subtleties of natural light. Here, as in so many Dutch sea paintings, it is the sky which has the greatest presence. Both boats and people are dwarfed against it.

A Courtyard in Delft at Evening
Pieter de Hooch
c.1656

A young servant girl carrying a jug and pail approaches an older woman, seated and spinning; nothing else is happening in this still, empty courtyard. Yet it is the extraordinarily satisfying way in which de Hooch has organised such ordinary components that makes his paintings so appealing.

A sharp edge of shadow leads our eye into the painting diagonally on a zigzag. Other diagonals are formed by the shaded gables of the distant house. All seem to converge upon the servant girl, bathed in sunlight, singling her out even though she modestly lowers her head. In the foreground a section of whitewashed wall is balanced by the high-builded bank of cloud in the top left corner. In addition to these subtle geometric ingenuities of design, there are the soft, beguiling glow of evening light and the warm textures of brick and earth.

De Hooch produced his finest work in his native Delft, roughly between the years 1655 and 1662. In later years his paintings lost the subtle, poetic powers seen in masterpieces, like this one, of refinement, order and restraint. One of George IV's last purchases, it was bought for the modest sum of £426 in 1829.

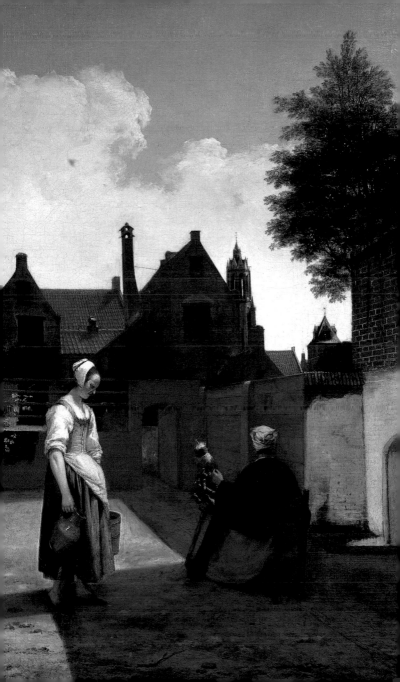

The Mystic Marriage of St Catherine

Anthony Van Dyck

c.1630

The infant Christ, seated on the Virgin's lap, is about to place a ring on the hand of St Catherine. This gesture symbolises their heavenly marriage. The Virgin observes the scene approvingly and carries a wreath of flowers for her son's bride. The scene is made more poignant by the fact that the saint rests her hand on the spiked wheel, the instrument of her torture, and she grasps a palm branch, signifying her victory over death.

The majority of works by Van Dyck in the Royal Collection are portraits, and so this beautiful religious painting is unusual. It was painted after the artist had spent some years in Italy, where he observed and sketched Italian paintings. He was particularly influenced by the art of Titian, as can be seen in the warm colours, broad brushstrokes and flowing treatment of fabrics in this painting. It is exceptionally lyrical – the intimate glances between the three figures and the echoing lines of cloth and gesture are harmonious and subtle.

The painting seems to have been presented to Charles I by his agent in Brussels, Sir Balthasar Gerbier. However, it left the Royal Collection soon after, and was purchased by George IV in 1821.

K.B.

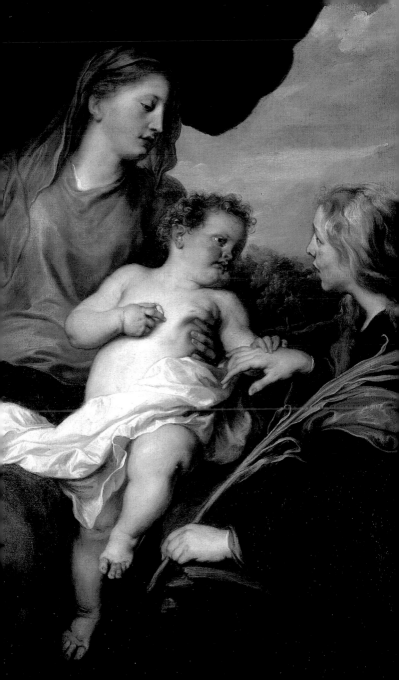

'The Farm at Laeken'
Peter Paul Rubens
c.1618

Rubens was an artist of extraordinary versatility. He was
perfectly at ease with the demands of grand, monumental
public commissions: religious altarpieces for churches, political
or mythological allegories for palaces. In these he was
spectacularly successful and his talents were much sought
after throughout Europe. His own patrons, the Archdukes of
the Spanish Netherlands, particularly favoured his devout

Catholicism and his depiction of his native country as prosperous and independent.

Privately Rubens enjoyed painting landscapes, usually for his own pleasure or his own family, but certainly not for his royal or aristocratic patrons. Because of this, their brushwork is even more fluid than usual. By the eighteenth century, however, landscape painting had become fashionable among collectors. The King of France tried unsuccessfully to acquire this one in 1746, but it was bought by George IV in 1821 for Carlton House.

Vibrantly coloured, full of harmonious rural activity and generously detailed, Rubens's landscapes are supremely benign representations of his native Flemish countryside. Figures, animals and landscape all appear ideally healthy, fulsome and rounded.

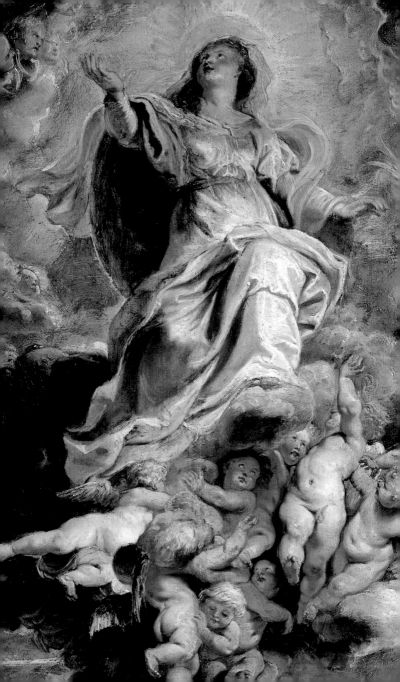

The Assumption of the Virgin
Peter Paul Rubens
c.1611

During the seventeenth century the Assumption of the Virgin became an immensely popular subject for painted altarpieces within the Catholic world. In the aftermath of the Reformation, the subject was used to promote the cult of Mary in order to distance Catholic doctrine from its Protestant rival.

The Assumption is not a biblical story, but a later tradition from the fourth century AD. It was finally written down in the Middle Ages in a book called *The Golden Legend*. Rubens shows Mary after her death, being taken up or assumed into heaven, supported by a mass of cherubs. Below her the apostles and holy women search her empty tomb in amazement. To the sides some of them watch her ascent.

This is a sketch for a larger altarpiece. For this reason it lacks detailed finish, but it was admired for the expressive fluency of the brushwork as Rubens worked out his final design. Its style, as well as its subject-matter, could hardly be more different from the Dutch seventeenth-century paintings collected by George IV. Yet it was bought by him in 1816 to hang at Carlton House.

The Listening Housewife
Nicholas Maes
1655

A woman quietly descends a tightly spiralling staircase, holding on to a rope for support while lifting a finger to her lips to invite us to be silent – so that we, like her, can listen to the clandestine lovers embracing in the cellar below. Beside them stands an older man with a lantern.

Paintings such as this seem to have been intended to convey some sort of moral message, although the precise meaning here is difficult to define. For example, the cat, asleep on a chair, is often used as a symbol for uncontrolled erotic desire, and the map on the wall can represent the pursuit of worldly pleasure. It seems then that the lovers may not be innocent. Yet the woman on the stairs is smiling – as if enjoying, and not necessarily judging, what is going on below stairs. Such ambiguity may have been intentional.

The lighting effects are dramatic – which is something that Maes, a pupil of Rembrandt, would have learned from his master. He has signed and dated the painting on the bottom step of the stairs. George IV bought it at auction in 1811 to hang at Carlton House.

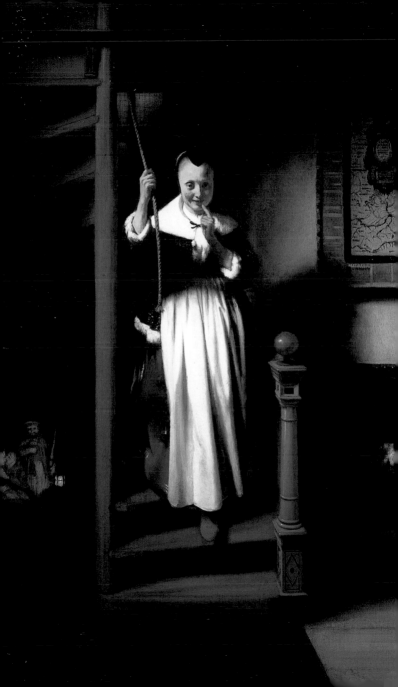

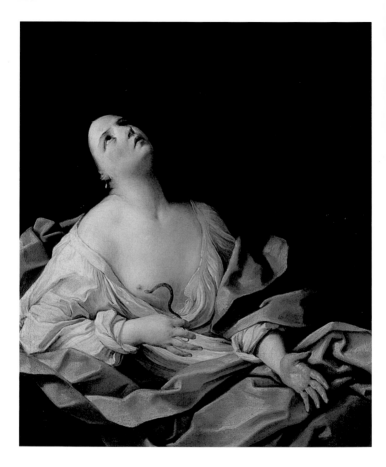

The Death of Cleopatra
Guido Reni
c.1630

As the doomed Queen of Egypt leans languidly backwards, the small poisonous snake, traditionally an asp, which she holds in her hand prepares to bite her breast. She looks imploringly upwards, perhaps asking the gods' forgiveness or lamenting her lost lover, Mark Antony, whose desertion has driven her to suicide. Reni describes her final act of despair avoiding any emotional violence. Roman historians record that the snake bit her on the arm, not the breast, but like other Italian artists of his day Reni presumably wanted to add a hint of eroticism. The painting was commissioned by a wealthy Venetian merchant, but this was a popular story and Reni made a number of copies of the composition.

It was bought by Frederick, Prince of Wales, the son of George II, in 1749 when the vogue for Reni's work was at its height. Frederick was a discerning and effective collector of paintings, hanging them in specially commissioned frames. He considered this to be one of his most valued acquisitions.

Mrs Jordan and Two Children
Francis Chantrey
1834

Mrs Jordan, the most celebrated comic actress of her day, was the mistress of the Duke of Clarence, later William IV. They had five sons and five daughters and lived happily but discreetly together at Bushey Park, next to Hampton Court Palace. She often paid the Duke's debts from her own earnings. In 1811 they parted. Thereafter, she lost the remainder of her fortune and died alone in poverty in France. Consumed with guilt, William IV commissioned the statue on succeeding to the throne in 1830. He wanted it to be placed in Westminster Abbey but the Dean refused. It remained in Chantrey's studio until one of William and Mrs Jordan's children, an Anglican clergyman, placed it in his church. In 1975 one of his descendants bequeathed it to The Queen.

The sculptor, Sir Francis Chantrey, has carved Mrs Jordan with two of her children. In classical art the personification of Charity is a mother breast-feeding her young and Chantrey probably referred to this tradition as a compliment. A contemporary critic, William Hazlitt, wrote of her: 'Her face, her tears, her manners were irresistible. Her smile had the effect of sunshine and her laugh did one good to hear it . . . She was all gaiety, openness and good nature.'

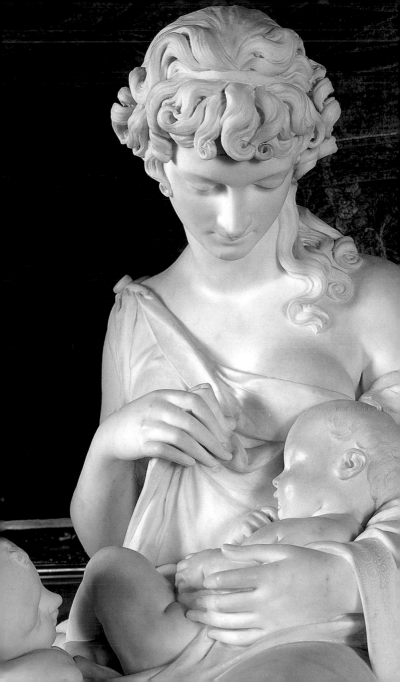

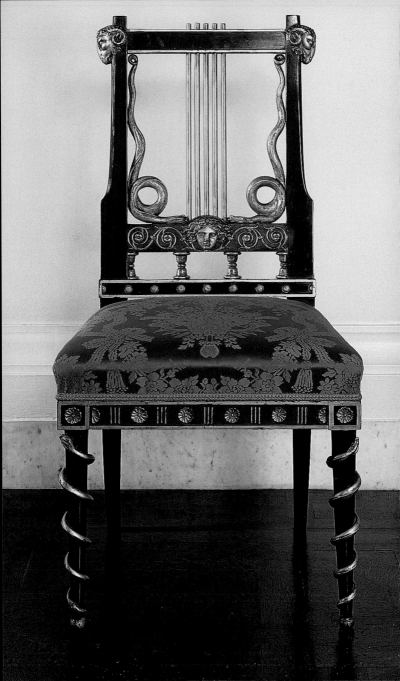

Lyre-backed Chair

c.1790

This chair was probably one of a set of twelve supplied by the French-born Francis Hervé for the Dining Room of Carlton House. It is made of carved mahogany with gilt detailing. The motifs are classical in origin but owe much to examples of eighteenth-century French furniture: the four gilt rods, for instance, that form the backrest and the curved outer edge of the side pieces are designed to recall the lyre, the small harp used in performance by ancient Greek and Roman poets. The face beneath them and the rams' heads above, as well as the rosettes on the seat rails above the legs, are also taken from classical ornament.

The two pairs of snakes which are wittily introduced in the open-work back and coiled round the two front legs belong to an English rather than a French style of ornament – so that the chairs would appear to combine two distinct, traditional reworkings of classical decoration.

The Prince Regent kept one of the finest kitchens in the civilised world. Critics attacked him for his love of food. If these are the chairs that were made for the Dining Room at Carlton House, they would have witnessed scenes of unsurpassed culinary indulgence.

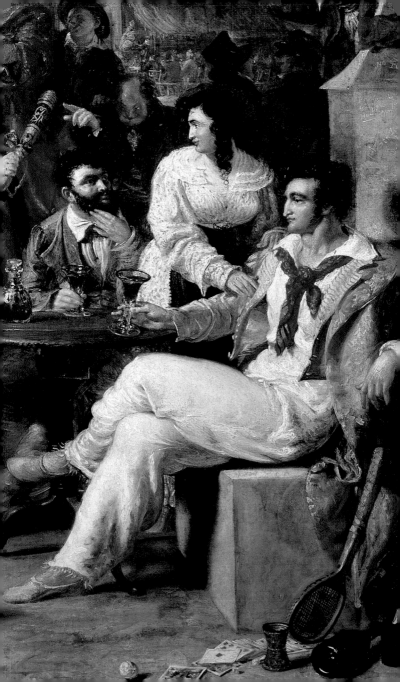

The Mock Election
Benjamin Robert Haydon
1827

The painting records a real incident observed by the artist while in a debtor's prison. The inmates, dressed in fantastic clothes, have staged an imaginary contest to elect a member to plead for their parliamentary rights. The painting's pair, *Chairing the Member* (in the Tate Gallery), shows the successful candidate enthroned after the election.

The painting is full of incident and detail. The characters appear to be 'types' – for example, the handsome Byronic rake in the foreground with his glass of wine, tennis racquet and playing cards. In fact, the artist returned to the prison to paint the portraits of the individual electioneers after he had been released. The soberly dressed couple in the foreground are depicted as the victims of the legal system: the man is clutching a paper which describes the impossible financial demands that led him to this terrible place.

Haydon was one of the most prominent artistic figures of his day, but he was unsuccessful in his chosen career as a history painter. George IV purchased this painting in 1828 and Haydon hoped that it would lead to further patronage from the King. Unfortunately it did not, and debt and depression eventually led to the artist's suicide.

K.B.

Pietra Dura Table
Morel and Seddon
c.1828

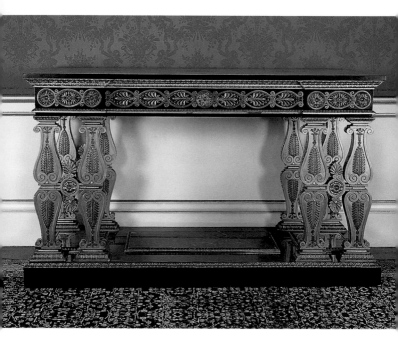

Eight carved and gilt legs support a large black marble slab, inlaid with different coloured marbles depicting a profusion of parrots, fruits, flowers, branches and trees in pietra dura (see pp. 118–19). The top was made in Florence in the late seventeenth century. The shapes of the legs resemble the forms of a famous bedstead made for Napoleon as well as

the detailing of the interiors of palaces designed by the French architect Charles Percier. Consequently the table was once thought to be French.

In fact George IV had this table made in around 1828 by one of his most favoured firms of English furniture-makers, Morel and Seddon, who employed as one of their designers François-Honoré-Georges Jacob-Desmalter (see p. 32). The gilt bronze, honeysuckle and palm-leaf ornaments on the legs and frieze are also French in style.

Such was George IV's passion for works of art and interior design that he also once provided the pattern for a carpet himself. This was made by Thomas Moore of Moorfields for Carlton House in 1792.

THE SILK TAPESTRY ROOM

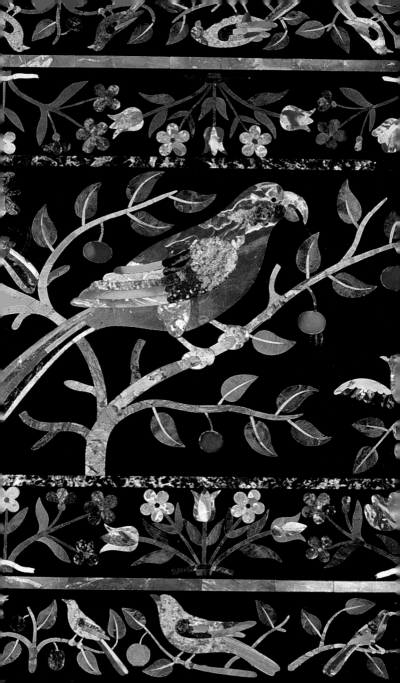

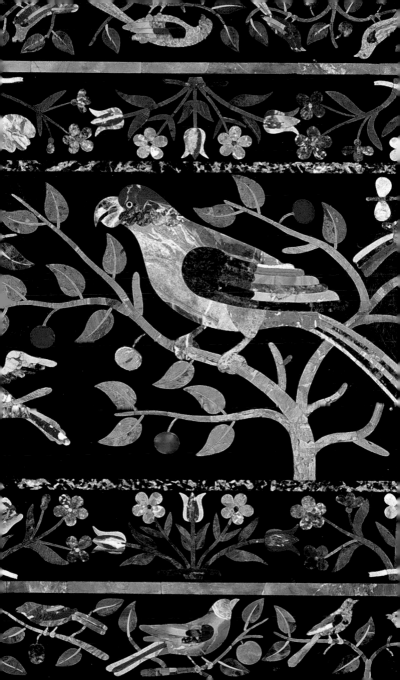

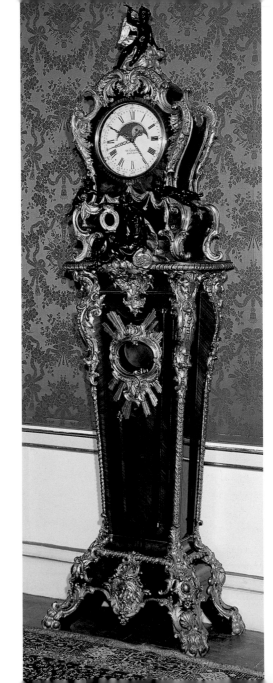

Monumental Pedestal Clock

c.1730

George IV was so proud of this clock, which he purchased in 1816, that he placed it prominently at the foot of the main staircase at Carlton House. It was an interesting choice because the rococo style was not particularly fashionable at the time. It is richly ornate in its materials, decorative detail and the curved, swelling shapes and silhouettes of the design as a whole. Made of oak veneered with tulipwood, purplewood and mahogany, it is fitted with elaborate chased gilt and patinated bronze mounts.

The case was most probably made by Parisian cabinet-maker Jean-Pierre Latz in the 1730s though it is stamped by François Duhamel, a furniture-maker who also worked as a dealer. The clock is reputed to have been made originally for the French royal Palace at Versailles, a provenance which would have appealed greatly to George IV. The dial and movement were replaced by Vulliamy in the nineteenth century.

The figure beneath the dial is intriguing and enigmatic She may be Danaë, a nymph from classical mythology who was seduced by Jupiter. He gained access to her sequestered bedroom by entering it in the form of a shower of golden coins.

Queen Charlotte with Her Two Eldest Children
Allan Ramsay
c.1764

Queen Charlotte is seated with Prince Frederick on her lap; Prince George (later George IV) stands holding a bow. Like Van Dyck, his illustrious predecessor as Court Painter, Allan Ramsay has cleverly combined a formal setting with what is essentially an intimate family group. The columns and the diagonal swathe of green drapery are imaginary, but they lend the figures grandeur. Mother and sons have been formally composed in a neat triangular arrangement, emphasised by the edges of the Queen's skirts and a portfolio propped up against the spinet. At the same time, though, the Queen protectively clutches her younger son, while Prince George, posed somewhat self-consciously, leans affectionately on her right knee. Queen Charlotte, incidentally, was very musical and her playing was noted with approval by Joseph Haydn.

The book on the spinet is John Locke's *Some Thoughts Concerning Education*. Other objects develop the idea of childhood play and learning: music (the spinet), art (the portfolio) and the military (the bow and the drum).

Allan Ramsay was much favoured by George III and Queen Charlotte – so much so that he spent almost his entire career working on various royal commissions. Unlike his contemporary, Sir Joshua Reynolds, whom the King and Queen disliked, Ramsay could converse quite ably in the Queen's native German.

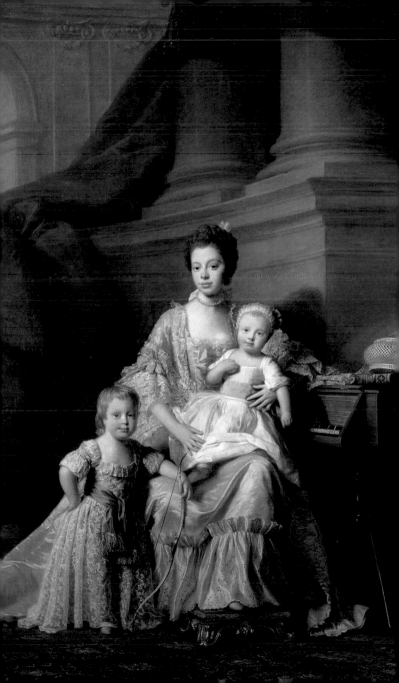

Equestrian Statue of Louis XV
Louis-Claude Vassé

1764

The original life-size statue of the French King on horseback, made in 1763 by the sculptor Edmé Bouchardon, stood proudly, all thirty tonnes or more, in Paris in the Place Louis XV. Evidently Bouchardon had a favourite horse which he used as a model because it was able and willing to hold a pose for three hours at a time. Although the sculpture was much admired, it was destroyed by the Revolutionary edict of 1792 which called for all royal monuments to be pulled down. Shortly after its place was taken by the Guillotine and the square was renamed Place de la Concorde. The right hand of the King, all that survives from the original statue, now rests in the Louvre.

This bronze reduction was one of seven made by the sculptor Louis-Claude Vassé, Bouchardon's pupil. These were given to the King, his mistress and other powerful individuals.

The French King is shown as a Roman emperor – accurately, too, in so far as the ancient Romans lacked the stirrup and none is shown here. Both Bouchardon's original and Vassé's reduced copy balance horse and rider on just two legs – technically no mean achievement.

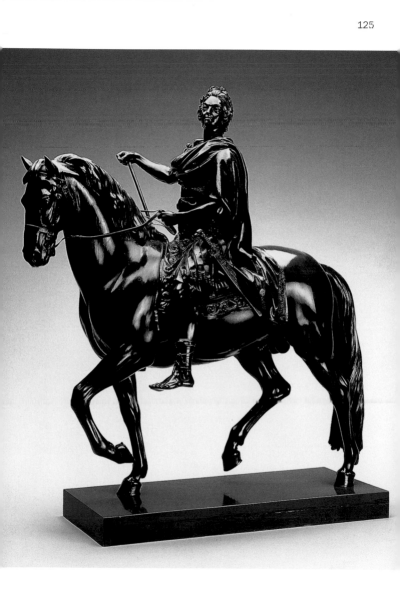

Console Table
Adam Weisweiler
c.1785

The thick slab of Italian red granite that forms the top of this
table is so heavy that the legs had to be made out of steel
to support its weight. In addition they are braced with a
handsome, interlaced stretcher – a device that is characteristic
of the maker of the table, Adam Weisweiler. Their strength is
remarkable, considering their tapering form and the elegant
female busts with which they are crowned. The rest is oak
veneered with ebony, mounted with gilt bronze. On the front
and sides are four pietra dura panels representing clusters
of fruit of the same date and style as those on the cabinet
by Carlin (pp. 44–5); in the corners, oval panels of red marble.
In the centre a bronze plaque depicts an allegory of learning –
DOCTRINA – with infants playing with books, drawings and
scientific instruments.

Adam Weisweiler (see p. 38) was a renowned furniture-
maker of German origin who worked in France for the French
royal family and, later, for Napoleon.

George IV bought the table from a Parisian dealer in 1816
for Carlton House. The relatively small scale of the rooms there
determined the size of the furniture chosen to adorn them.

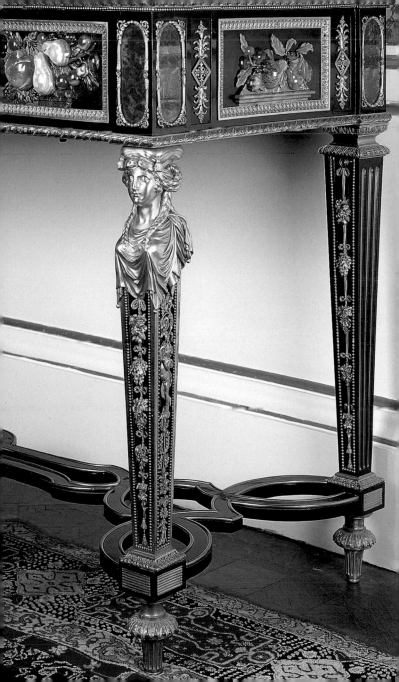

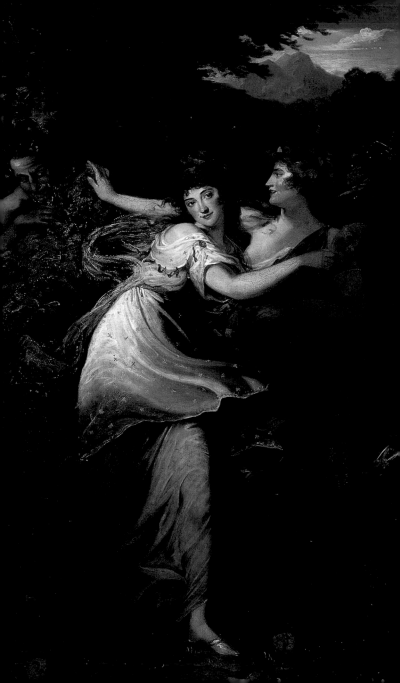

Mrs Jordan as the Comic Muse
John Hoppner
1786

Mrs Jordan's success as a comic actress was at its height
when this painting by Hoppner (see p. 194) was made and
she had her portrait painted by other prominent artists soon
afterwards. The tradition of portraying actors and actresses
in a particular theatrical role or as a symbolic figure had
been well established earlier in the century and this picture
is a fine example.

The actress is not shown in character here, but rather as
the personification of her art – she carries the smiling mask
of comedy. She is running from the advances of a satyr,
half-man, half-faun, and is attended by one of the Graces,
a personification of comedy. The lecherous satyr adds a
certain tension to the composition and may symbolise the
male audience. The brilliant colours and swirling fabrics are
appropriate to a theatrical sitter, and the actress stares directly
at the viewer.

The portrait was exhibited at the Royal Academy in 1786
and was bought by William IV in the 1830s. Mrs Jordan had
been the King's mistress for many years (see p. 110), but
he ended their relationship to marry a suitable bride. This sad
tale is hard to equate with the flushed, youthful woman in
the painting.

K.B.

Christiansborg Palace from Højbro Square, Copenhagen

Heinrich Hansen

1863

This is one of a pair of paintings presented by the people of Copenhagen to Princess Alexandra of Denmark (see p. 186) on the occasion of her marriage to the future King Edward VII in 1863. This is recorded, in Danish, in an inscription around the frame of each painting. They were an appropriate gift as they depict the two main Danish royal residences. The other painting, also in the East Gallery, shows Bernstorff House, the summer residence of the Danish royal family.

Hansen specialised in architectural painting and in this carefully composed view of Copenhagen he provides us with an accurate representation of one of the most historic parts of the city – the Palace Island with Christiansborg Palace, now the Danish parliament building, dominating the right side of the composition. Højbro Square in front of the Palace was the location of the fishmarket and the artist has taken great pleasure in painting details of everyday life. In the right foreground apple-sellers who advertise their wares on wooden lattices stand near the fishermen. This distinctive practice has been revived recently and can be seen in Copenhagen today. In fact visitors to Copenhagen will discover that this view is still clearly recognisable. K.B.

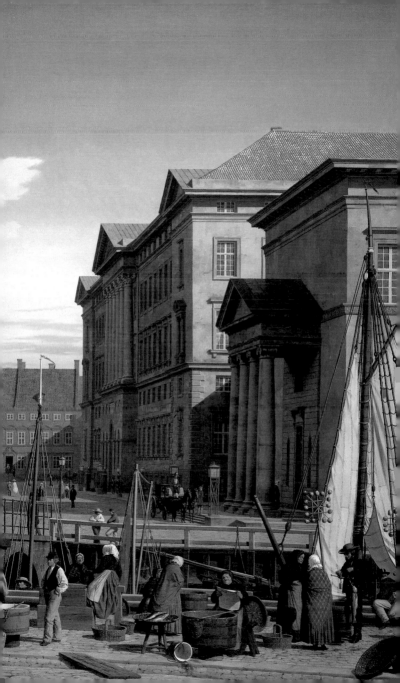

George IV when Prince of Wales
John Russell

1791

George IV is renowned for his dissolute private behaviour.
His continuous excess later caused obesity and swollen
glands on his neck, which he hid behind high collars and full
cravats; these subsequently became highly fashionable attire.
He was also to suffer badly from gout, which he treated with
laudanum (a derivative of opium) and cherry brandy.

None the less, George IV was the keenest, most
knowledgeable and most successful royal collector since
Charles I. The richness and splendour of Buckingham Palace,
both in its architecture and furnishings, are his legacy.

He is shown here while still Prince of Wales, in the green
uniform of the Royal Kentish Bowmen, of which he was
President. He leans on the pedestal of a statue of Diana, the
classical goddess of hunting and chastity. He is not yet overly
fat, yet something of his epicurean character is suggested by
his pose, hair and expression. His brother once tried to lure
him to a Kentish Bowmen dinner by promising him turtle and
venison – served in tents in rural Surrey.

The painting was commissioned by George IV as a prize
for a meeting of the Bowmen in the 1790s and was bought
by his great-nephew King Edward VII in 1908.

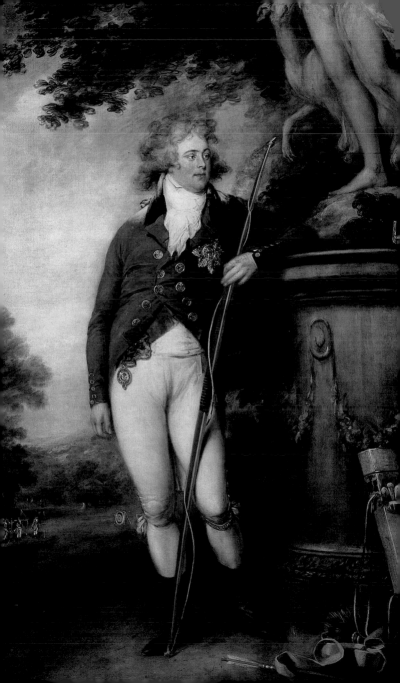

The Coronation of Queen Victoria

George Hayter

1838

It is said that 400,000 people slept in the streets of London the night before Queen Victoria was crowned, to watch her process to Westminster Abbey. She was the first ruler to leave for a coronation from Buckingham Palace.

The painting depicts the moment just after the crown has been placed on the monarch's head, when the people call out 'God Save the Queen' and the peers put on their coronets. They and the rest of the crowd are in celebratory movement while the young Queen is solemn and still. She wears the Imperial Mantle and holds two sceptres. To keep the Queen as the prime focus, Hayter illuminated her brightly – beams of light seem to fall diagonally towards her.

The ceremony on 28 June 1838 was far from perfect. The clergy were uncertain of their roles and concluded the proceedings too early; the choir was inadequate; and an aged lord needed to be refreshed with a glass of wine in a private chapel. Queen Victoria found the throne too low and the orb too heavy and had to soak her swollen finger in iced water after the Archbishop of Canterbury forced the ring onto the wrong finger.

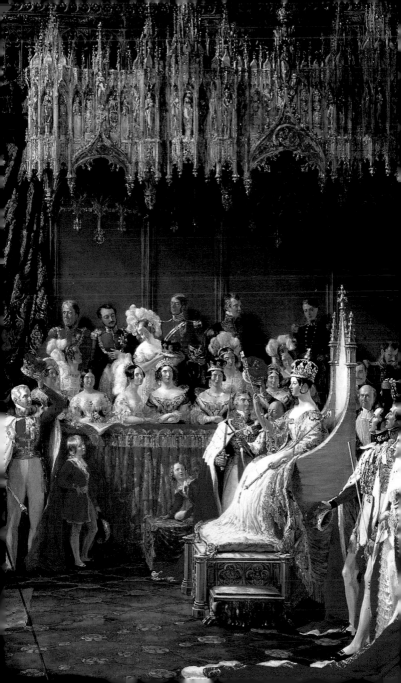

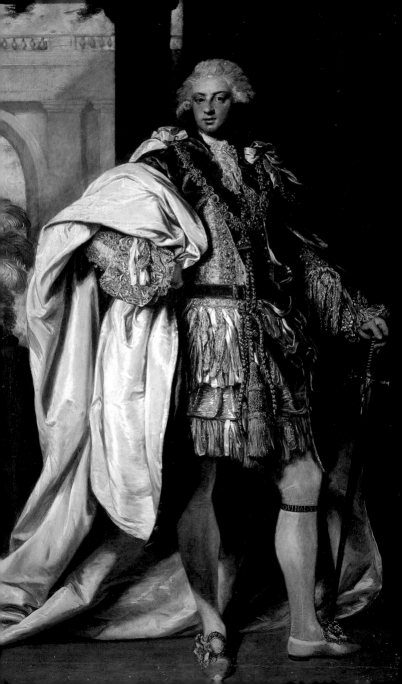

Frederick, Duke of York
Joshua Reynolds
1788

Reynolds was the first president of the Royal Academy of
Arts, the author of an enormously influential series of lectures
entitled 'Discourses on Art' and the foremost portrait painter of
his day. Yet he was studiously ignored by the King, George III,
who patronised a wide range of other contemporary painters
but only rarely Reynolds himself. Part of the problem lay with
the unruly behaviour of the King's eldest son, later George IV,
whose wayward friends included some of Reynolds's own circle
of acquaintance.

Reynolds also had a tendency to give his portraits the
intellectual weight of more elevated types of picture – stories
from the Bible, for instance, or classical mythology. George III
was more literal minded; for him such an approach would have
appeared pretentious.

This portrait of King George's second son, Frederick, Duke
of York, was most probably commissioned by his brother
George IV when he was still Prince of Wales, to hang at Carlton
House. Certainly almost all the other works by Reynolds now
in the Royal Collection were acquired by George IV. The Duke
wears the robes of the Order of the Garter, the ancient chivalric
order established by King Edward III in the fourteenth century.

Caroline, Princess of Wales, and Princess Charlotte
Thomas Lawrence
1802

Princess Caroline, wife of the future George IV, plays the harp while their daughter, Princess Charlotte, hands her some music. Caroline was evidently an accomplished performer on the instrument, and Lawrence has complimented her skills by including a bust of Minerva, the classical goddess of wisdom and patron of the arts.

It is a dramatically composed painting. The viewpoint is low and the harp foreshortened, emphasising the height and elegance of the Princess. Lawrence has spotlit the faces of mother and daughter while keeping the surrounding colours darker in tone; these are in turn offset by touches of red.

Princess Caroline's marriage with the Prince of Wales was disastrous. The Prince had already secretly married his Catholic mistress, Mrs Fitzherbert. He was appalled by his new wife's lack of sophistication; her bad teeth and habit of not washing regularly particularly repulsed him. He was drunk throughout their marriage ceremony. Shortly after the birth of their daughter Princess Charlotte the couple separated. The scandals continued. Princess Caroline was rumoured to have had an affair with Sir Thomas Lawrence while he was painting this portrait. When the Prince of Wales finally acceded to the throne he barred Caroline from the coronation. She died shortly afterwards.

Chinese Vases with Gilt Bronze 'Snake' Mounts
Mounts by Vulliamy 1810–14
early nineteenth century

The four large porcelain vases in the Gallery were made in China about 1800. They are decorated in a style known as *famille rose* after the predominance of pink in the colour scheme.

Two of the vases include bats and clouds in their decoration; the Chinese character for bat is pronounced in the same way as the character meaning good fortune, and clouds are similarly traditional symbols of luck and happiness.

George IV bought all four vases in 1810. He then sent them to the Vulliamys, his favoured firm of clockmakers and bronze manufacturers, for the gilt bronze snakes and marble plinths to be added. The vases remained with the Vulliamys for a staggering four-year period, during which over thirty firms or craftsmen were involved. All the names of those involved are recorded in the extensive Vulliamy archives, from the modeller who formed the snake handles in wax before casting to the man who gilded the finished bronzes four years later.

An earlier bill for another pair of snake-handled vases may explain the alarming realism of the snakes; it reads 'the Snakes copied from Nature one having been caught & moulded on purpose'.

M.W.

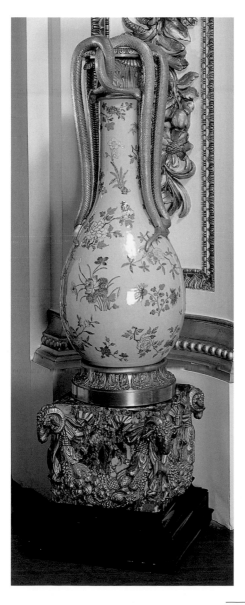

'Sancho Panza Despairs at the Loss of His Donkey'
Gobelins Tapestry

second half of eighteenth century

The four tapestries are part of a series of twenty-eight depicting scenes from Cervantes's novel *Don Quixote*. Here Don Quixote's manservant Sancho Panza reacts with fury on finding that his ass has gone missing. The tapestries were made at the French royal factory at the Gobelins, near Paris. Evidently the borders were considered more important than the scene depicted – the designers were paid more than the artist who provided drawings for the figures.

The tapestries were given to the artist Richard Cosway in 1787 by the French King, Louis XVI, in recognition of a gift of some sixteenth-century Italian works of art Cosway himself had made to the French royal collection. In 1789 Cosway presented the tapestries to the Prince of Wales, thereby ingratiating himself with the next British monarch.

George IV had sat to Cosway for a miniature in 1780, at the age of 18, when he was still Prince of Wales. Cosway was much older than the Prince and a flamboyant, dazzling personality. He quickly became a friend and an important adviser to the Prince, who was starting to put together his own collection at Carlton House.

Boulle Knee-hole Desk

late seventeenth century

George IV had a particular fondness for Boulle marquetry
(see p. 61). Over the years he collected a number of pieces
of furniture that incorporate this special technique of metal
and tortoiseshell inlay. These range in date from the late
seventeenth to the early nineteenth century.

This desk is an early example, dating from the late
seventeenth century. It is French, though the maker's name is
unknown. At Carlton House George IV often displayed Sèvres
porcelain vases on pieces of Boulle furniture, either singly or in
groups (*garnitures*). The rich but sombre tones of the furniture
would have enhanced the strength of their forceful, brightly
coloured glazes.

The patterning has been delicately, if not whimsically,
designed: darkly silhouetted putti or Cupids tumble and cavort,
accompanied by dogs, birds and other animals amid leaves,
curling lines and swags. It is difficult to imagine anything too
grave or serious being written above such playful, pastoral
panels. George IV originally placed the desk amid the exotic
surroundings of his summer retreat, Brighton Pavilion.

Gilt Bronze Candelabrum
François Rémond
1783

This is one of four candelabra made for the Turkish Boudoir of Charles, comte d'Artois, in the Palace of Versailles. During the late eighteenth century Turkey was considered an exotic, distant land, full of the delights of the East. The Turkish style, like the Chinese and Indian styles, became very fashionable – although it was often reserved for smaller, more intimate interiors, where the slightly risqué appeal of the East was thought more appropriate. Although supposedly in the Turkish style, the candelabra are in fact of conventional late eighteenth-century French form. The designer has, however, included such 'Turkish' motifs as camels' legs, stars and crescents. The somewhat surprising use of maize sprouting from between the candle branches comes from the mistaken idea that maize originated in the Middle East (whereas in fact it came from South America).

The comte d'Artois was the youngest brother of Louis XVI. During the French Revolution and the Napoleonic Wars he lived in exile at the Palace of Holyroodhouse in Edinburgh. He ascended the French throne as Charles X in 1824 but abdicated in 1830. Lady Holland described him as 'a man of slender abilities with violent passions; before the revolution . . . weak and volatile . . . now weak and revengeful'.

M.W.

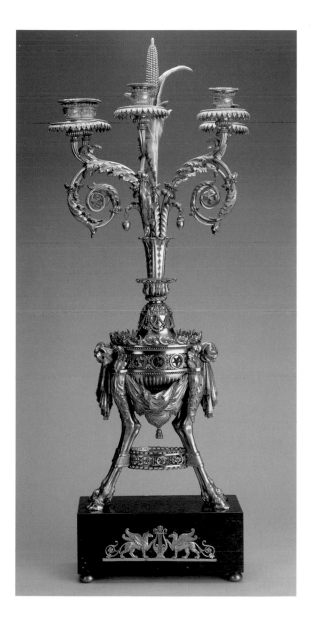

Apollo Clock
Pierre-Philippe Thomire
c.1810

Apollo, classical god of the sun, drives
his chariot over a semi-circular frame
representing the arc of heaven spilling over
with golden wisps of cloud. The face of the
clock has been cleverly incorporated in the
wheels of his chariot. Signs of the Zodiac
have been mounted on the blue metal arch.
The clock is by Pierre-Philippe Thomire, one
of the finest French bronze-makers of his day,
whose long career spanned the years of the
Revolution. Perhaps therefore it is fitting that
this clock displays his sculptural skills more
clearly than it does the time. This emphasis
would not have troubled George IV, though his
father, George III, was an amateur horologist
with a keen interest in the science of time.

The clock was bought by George IV
through an agent in 1810, when Britain
was at war with France. A few years later,
in 1813, Napoleon realised that his embargo
on trade with Britain was actually harming
French commercial interests and he allowed
a selected number of enterprises to sell
goods to the British. George IV was quick
to seize the opportunity and bought a
shipment of candelabra and other clocks
direct from Thomire.

THE STATE DINING ROOM

George III
Allan Ramsay
c.1763

In this splendid portrait George III is shown in gold coat and breeches, wearing his coronation robes and surrounded by rich fabrics. The King is both elegantly and comfortably posed, resting his right hand on his hip. The diagonal position of his left arm and thigh are continued by that of the red drape behind him.

Ramsay's painting proved immensely popular and he was inundated with orders for copies.

Ramsay had painted the King before, while he was still Prince of Wales. It seems the two men had much in common. Both pursued intellectual interests. Ramsay corresponded with some of the most advanced thinkers of the day (Hume, Rousseau, Voltaire) and was a friend of Samuel Johnson. The King built up an enormous library at Buckingham House, which he made available for scholarly research. It was used by (amongst others) Samuel Johnson. He also instructed those who bought for him at auction 'never to bid against a scholar, a professor, or any person of moderate means who desired a particular book for his own use'. The 67,000 volumes were subsequently dispersed, the majority of them being given by George IV to the British Museum.

Clock
Benjamin Vulliamy
1788

The dial of the clock is set within an emblem of decay –
a broken column – and to the side lies another, an upturned
Corinthian capital. An angel points to the dial while holding a
wreath of laurel; an infant holding a sextant is poised between
the angel and another figure who reclines in front of a huge
telescope, pointing to an astrolabe. The wreath normally
represents fame, the sextant and the astrolabe stand for
human learning; it is as if the child is submitting man-made,
mechanically derived knowledge to divine authority, for it is
the angel who pronounces the allocation of fame.

The clock was designed by Benjamin Vulliamy (see p. 34)
for Carlton House in 1788. It is a good example of the
restrained Neoclassical style of object which George IV
collected early in his adult life. The figures are biscuit
porcelain, modelled by the sculptor Jean-Jacques Spengler
for the Derby factory. Clocks containing porcelain figures
were highly fashionable at the time.

Silver-gilt Centrepiece with Queen Victoria's Favourite Dogs
Modelled by Edmund Cotterill for R&S Garrard, from designs by Prince Albert
1842

Among his many artistic interests Prince Albert was concerned to promote good design in the applied arts, and this architectural centrepiece, with echoes of German Renaissance silver, was his own work.

Throughout her long life Queen Victoria surrounded herself with dogs, of which the names of more than 300 are recorded. Here, pride of place is given to Eos, a greyhound bitch, Cairnach, a Skye terrier, Islay, a rough-haired terrier, and the dachsund, Waldman.

The centrepiece was shown at the Third Annual Exhibition of British Manufactures at the Society of Arts in 1849.

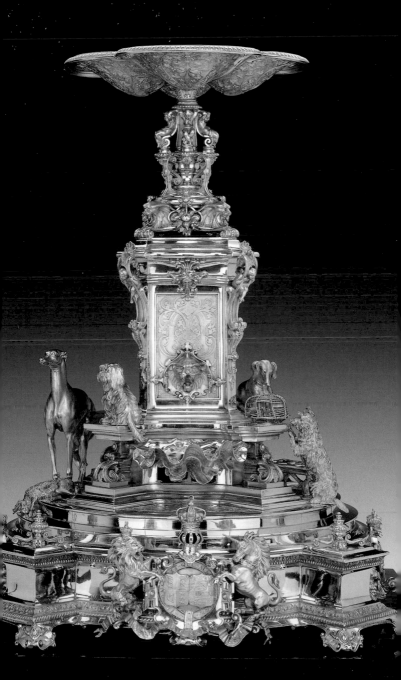

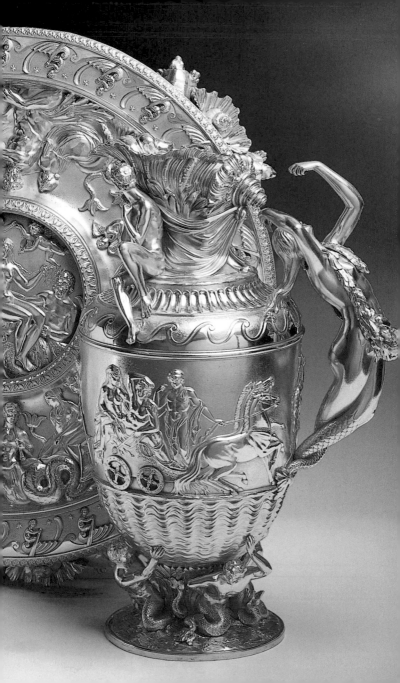

Silver-gilt Ewer and Stand
Rundell, Bridge and Rundell

1822–3

This is one of a pair of ewers and stands that were made
for George IV in 1822. Their richness and superb quality are
typical of the King's taste and reflect his desire to dazzle and
delight his guests. In 1811 he had given a fête at his London
Palace, Carlton House, in honour of his father's birthday. The
3,000 guests dined at a table loaded with elaborate silver-gilt
arranged around an artificial stream with mossy banks in which
real goldfish swam.

The ewer and stand are decorated with the figures of
Neptune and his wife Amphitrite with mermaids and tritons.
The cast turtles, which support the stand, would have
complemented the turtle soup that was one of the King's
favourite dishes.

These watery themes originated with a service made for
George IV's grandfather in the 1740s. George IV continued
to add new pieces and ran up huge bills with his principal
goldsmiths, Rundell, Bridge and Rundell. His largest single
order came to the vast sum of £70,000 in 1806, the
equivalent of many millions of pounds today. Much of the
silver-gilt made for George IV is still used for State Banquets
at Buckingham Palace and Windsor Castle.

M.W.

Candelabrum
attributed to François Rémond
c.1787

In the aftermath of the Revolution, in 1793, the successful
and prosperous furniture dealer Dominique Daguerre fled
from his establishment in rue St Honoré, Paris, to his shop in
Sloane Street in London. Daguerre supplied much of the up-
to-date furniture for the most influential collectors of his day.
In France he provided numerous items for Marie-Antoinette.
From London he supplied many pieces of furniture and other
objects for George IV at Carlton House. It is likely that these
two pairs of matching candelabra were among the items
George IV procured through Daguerre's offices.

At the centre of the chased and gilt bronze framework is a
blue vase crowned with a flaming torch. Tripod legs with animal
feet, spiralling serpents, eagle heads and hanging chains make
up the rest of the fanciful ornament. It is possible that these
candelabra were produced by the renowned French bronze-
maker François Rémond. What is certain is that George IV
valued them extremely highly. Whereas most of the furnishings
of Carlton House were subject to continuous alteration or
change, these were never moved from the Great Drawing
Room. Accounts recording various repairs also testify to
their importance.

Shakespeare
William Pitts
1835

George IV and John Nash commissioned William Pitts to celebrate England's literary past in three of the moulded plaster reliefs in the tympana – that is, the central over-arches between the columns and the ceiling. The reliefs were based on designs by Thomas Stothard, and the choice of writers to be honoured is interesting: Spenser (above the door from the Dining Room), Shakespeare (above the door to the White Drawing Room) and Milton (opposite Shakespeare). Spenser and Milton are not widely read today, but the early nineteenth-century poet John Keats, who died just after George IV came to the throne, considered these three figures as the greatest and most inspirational exemplars from the past. Milton is best known for his Christian epic, *Paradise Lost*; after the Civil War he also wrote pamphlets on behalf of the Parliamentarians defending the execution of the monarch, Charles I.

Shakespeare, like the other two, is seated on a throne at the centre of the relief. Airborne putti hold a wreath of laurel behind his head. He is flanked to left and right by angelic figures holding lyres, classical attributes for poetry. Further to the sides are two figures representing Comedy and Tragedy, identifiable by their masks.

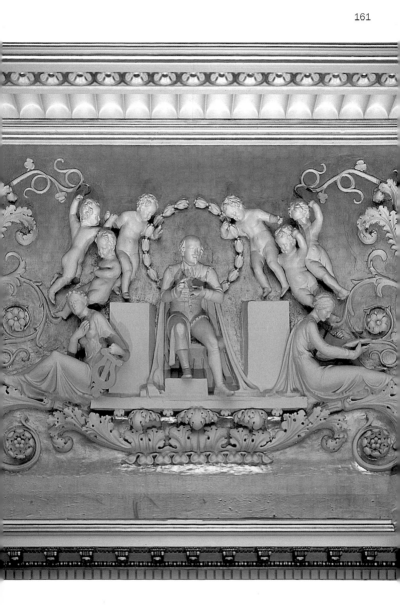

THE BLUE DRAWING ROOM

'Vase Royal'
Sèvres
1768–70

Queen Charlotte collected Sèvres porcelain and her example
may have inspired her son, George IV, in what was to become
a passion that lasted his whole life. Even as an invalid during
his final months he was still buying expensive pieces. At the
beginning he was encouraged by the dealer Dominique
Daguerre – the Sèvres agent in London (and also, incidentally,
the Wedgwood agent in Paris) (see p. 159). All in all, he
collected for nearly half a century.

This imposing vase combines many of the qualities for
which the Sèvres factory was admired: a strong, sculptured
form with highly inventive details (such as the doves holding
garlands and the cameo heads), and a superbly painted oval
derived from a painting by François Boucher. Finally there is
the gilding, picked out in a variety of ways by the burnisher,
using an agate stone to mark the fired gold.

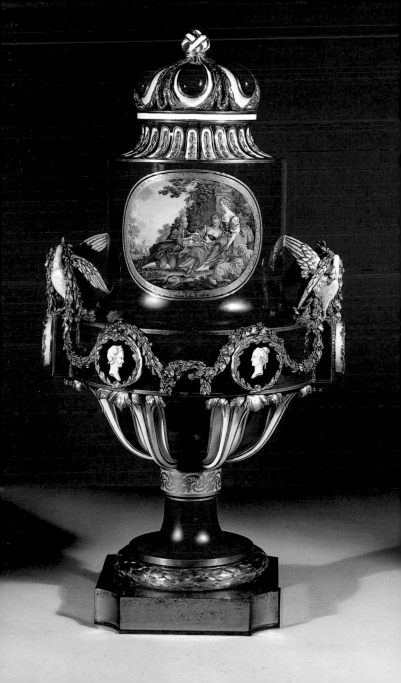

Side Table
Alexandre-Louis Bellangé

c.1823–4

This is one of a pair of tables bought by George IV at auction
in 1825. They were originally intended for Windsor Castle
but were installed in Buckingham Palace after the King's
death by his brother and successor to the throne, William IV.
William never lived in Buckingham Palace, preferring the

more domestic and congenial
surroundings of his home at
Clarence House. Because the
tables did not quite fit the recesses
between the columns the plinth
on which the legs rest had to be
slightly reduced – the alteration is
visible towards the right.

The tables were made in Paris
by Alexandre-Louis Bellangé, who
was one of a family of distinguished
nineteenth-century French furniture-
makers. They are built of oak,
though the front legs are of steel
and are mounted with gilt bronze heads. The decoration
of each head varies: the roses, corn, grapes and drapery
have tentatively been interpreted as emblematic of the four
seasons. They are further embellished with cornelian studs
and lapis lazuli. The panels between them are of antique green
marble. This type of decoration was inspired by the furniture
of the Louis XIV period, which George IV collected avidly.

Astronomical Clock
Jean-Antoine Lépine
c.1790

George IV bought this clock direct from its maker, Jean-Antoine Lépine of Paris, in 1790 to adorn Carlton House – though by 1797 it had still not been paid for in full. Its three dials provide comprehensive means of telling the time. One of the winged putti holds a pair of dividers to remind us of the mathematical calculations involved.

The hands of the central dial show the hours, minutes and seconds. A fourth hand indicates the difference between solar time and Greenwich Mean Time – the conventional measure used by most clocks and watches. The left-hand dial shows the day, month and year as well as the signs of the Zodiac while the right dial indicates the phase of the moon and the day of the week. The arch below the central dial shows the passage of the sun through the sky. The dials are made from soft-paste porcelain with jewelled enamelling; the rest of the clock is marble with elaborate gilt mounts.

The clock still retains its original movement. It is one of the few in the Royal Collection not to have had its insides worked on by the royal clockmaker, Benjamin Vulliamy.

Table of the Grand Commanders
Sèvres
1806–12

Napoleon commissioned this table in 1806 when he was at the height of his power. It is made almost entirely of porcelain and took six years to construct. The base is in the form of a shield, the support in the form of the 'fasces' – a bundle of staffs used to symbolise political authority in ancient Rome. The top is hard-paste Sèvres porcelain with elaborately painted and gilded decoration; in the centre is the profile head of Alexander the Great, surrounded by twelve smaller heads of other military commanders from antiquity. They are painted to resemble cameos set into gilt and green patinated bronze. Napoleon was thus comparing his own achievements with those of the classical past. The table was given to the Prince Regent in 1817 by a grateful Louis XVIII, newly restored King of France, two years after Napoleon's defeat. The Regent was immensely proud of it and ordered his painter, Sir Thomas Lawrence, to include it in all state portraits.

Like Byron and Turner, the most prominent literary and artistic figures of the Romantic period, the Prince Regent was obsessed with the career of Napoleon.

Ceiling

completed by 1830

The ceiling is the most imaginative and original of those designed by John Nash for George IV's new Palace. Nash had worked for George IV both at Carlton House and Brighton Pavilion. Both buildings boasted innovative, richly decorated ceilings. Furthermore, George IV had had a bow room of similar shape at the centre of his sequence of State Rooms at Carlton House and ordered Nash effectively to repeat the same arrangement here.

The ceiling consists of a richly patterned dome and a smaller, equally ornate semi-dome. Each is decorated differently. The dome is divided into diamond-shaped panels which contain the familiar emblems of the kingdoms of England, Scotland and Ireland – the rose, thistle and shamrock. The symbol of Wales, a principality, is not included. The four shields in the corners bear the Hanoverian arms, which serve as a reminder that between 1715 and 1837 the ruler of England was also the king of Hanover. The semi-dome is divided by five ribs. Each section is adorned with an overlapping or stepped pattern which is, in effect, a more delicate variation of that of the large dome.

Chandelier

early nineteenth century

It is best to imagine the chandeliers glittering and glinting with dozens of candles, and then to picture how this frozen waterfall of light would have been reflected by the hundreds of glass drops as well as the mirrored panels in the doors.

This example was probably brought from Carlton House; the chandeliers there were acclaimed at the time as the finest in Europe. Before the arrival of electric light in the domestic interior, the generosity and opulence of entertainments could be measured by the number of candles used to illuminate a room. One visitor to Carlton House, writing in 1813, found herself lost for words: 'I am afraid all my powers of description would fail to give you an idea of . . . the glitter of spangles and finery, of dress and furniture that burst upon you' (Lady Elizabeth Fielding, 10 February 1813). Much of the effect to which she found herself so susceptible would have been due to the lighting provided by chandeliers such as this one.

The glass and the light branches are suspended from eight gilded metal rings, in tiers. At the bottom twelve branches, decorated with acanthus leaf, curl outward, each with four branches. Above are further bands, glass spirals and festoons of innumerable prismatic drops.

Vase
Sèvres
1764

Much of the silver and porcelain acquired by George IV for
Carlton House and subsequently for Buckingham Palace
was intended for display rather than use. He admired Sèvres
porcelain above all, although he also collected Meissen, Berlin
and Paris porcelain and patronised British factories such as
Derby, Worcester and Spode.

This vase has unusual, angular handles threaded with oak
garlands, and towards the base raised zigzag and diamond
bands. The cover is of oak leaves and acorns. There are two
painted scenes: one of a spray of flowers; the other, somewhat
incongruously for a piece of such sophisticated craftsmanship,
of a brawl outside a tented camp.

The Sèvres factory owned a large stock of engravings after
artists such as David Teniers; these were used as patterns for
the porcelain painters.

The Sèvres factory sold its vases in sets of three or five to
form *garnitures* for chimneypieces. As in this instance, the sets
often included vases of quite different shapes.

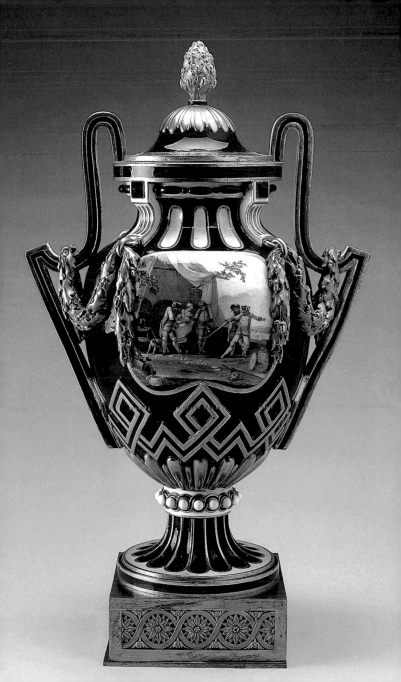

Wooden Cipher

1831

Only a tiny proportion of the Music Room floor is normally visible – most of it is covered with an enormous Savonnerie carpet. None the less, certain details can be glimpsed which give at least a taste of its intricacy and splendour.

The wooden floor was designed and made for George IV by Seddon, the firm of furniture-makers who supplied much of the furnishings for Buckingham Palace and other royal residences in the early nineteenth century. Radiating from the centre, and hidden from view, is a familiar royal motif: an enormous star. At the corners, partially visible, are four medallions each inlaid with the cipher of George IV in satinwood, rosewood, tulipwood, mahogany and holly. The cost of all this was high – £2,400, making it the most expensive floor in the entire Palace.

Again, an effort of the imagination is called for: the rhythmic beats of well-made, royal shoes marking out the steps of a dance; or the falling of drops of holy water on its expertly cut, dovetailed boards – the Music Room is traditionally used for royal christenings.

Ceiling

completed by 1830

This ceiling is another of Nash's more original contributions to the decoration of the Palace. It is divided into densely patterned segments and it cleverly plays simple convex and concave forms one against the other. In the centre are three shallow domes. These are flanked by narrow framing panels of acanthus, and they are connected to the walls by curving, lattice-patterned billows whose rounded shapes seem to recall the folds of a tent. By coincidence, when George IV was still living at Carlton House as Regent he was forced on occasion to use tented spaces in the grounds to provide enough room for guests on official occasions – the house itself was too small.

Beneath the ceiling there is a frieze of sculpted panels showing groups of children, each divided by heavy scrolls. Nearly all the panels stand directly above the flattened columns (or pilasters) with which Nash has decorated the walls beneath. Between the sculpted frieze and the pilasters there is a second frieze decorated with circular wreaths. In the centre of each one Nash has included a curious triangular device which resembles one of the more well-known Masonic symbols; both the architect and his patron were Freemasons.

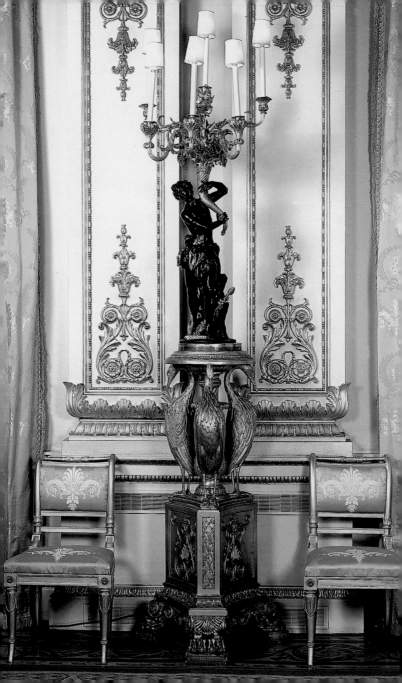

French Candelabra with English Pedestals in the Form of Cranes

late eighteenth century and early nineteenth century

The candelabra themselves are French and of the Louis XVI period. George IV had them placed on pedestals made by the firm of Tatham, Bailey and Sanders in 1811 for Carlton House.

The pedestals are of gilt beechwood. Ancient Roman marble pedestals of similar form had been engraved by the eighteenth-century Roman artist Piranesi, and it seems highly likely that this provided Tatham with the inspiration for their design.

The candelabra are of gilt and patinated bronze. In one a faun, in the other a nymph, holds a giant, twisting horn out of which bursts a garland of flowers and fruit. Out of these curl the branches for the lights. In classical mythology this is the cornucopia, or horn of plenty. The imagery is therefore classical in style and erudite in origin but exuberant and fanciful in spirit.

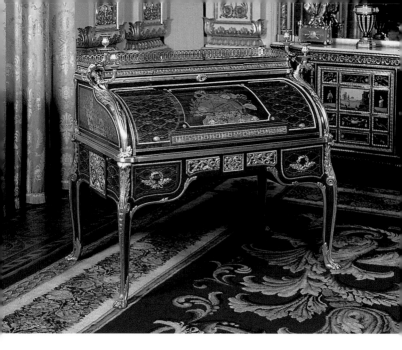

Roll-top Desk
Jean-Henri Riesener

c.1775–80

George IV took the opportunity to snap up this desk at auction in 1825 when a rich West Indian landowner was forced to sell his collection of furniture and paintings following severe financial setbacks.

Although the desk is not signed, it was undoubtedly made by Jean-Henri Riesener, cabinet-maker to the French Court and one of the finest furniture-makers of the eighteenth century. George IV believed that the desk had once belonged to

Louis XVI; in fact it was probably made for one of the daughters of Louis XV. This and a number of desks like it, all made for the French royal family by Riesener, are children of the great *bureau du roi*, made by Riesener and his master Oeben for Louis XV's use at Versailles. The desk is made from oak, veneered with a bewildering variety of different woods: purplewood, mahogany, casuarina, holly, box, sycamore and others. The marquetry is much faded but was originally stained in bright blues, greens and reds.

There are practical, as well as decorative, ingenuities about the desk. Riesener included a pull-out reading stand, a secret compartment and a locking mechanism that ensures the principal drawers cannot be opened when the roll top is closed.

Pietra Dura Panel
from Cabinet

early eighteenth century

For all the profusion and overwhelming richness of George IV's collections, certain preferences and patterns in his taste become apparent as one walks round the State Rooms of Buckingham Palace: his love of Sèvres porcelain, for example, of Boulle marquetry, of eighteenth- and nineteenth-century French furniture. This is another particular favourite: a pietra dura panel. In Italian 'pietra dura' literally means 'hard stone' but refers to inlaid decorative arrangements of semi-precious stones. In other examples on view in the Palace such panels have been set into cabinets (see pp. 38 and 44) or tables (see p. 116). Here they have been set into a pair of ebony and gilt bronze pier cabinets either side of the fireplace. Originally from Carlton House, they were altered and moved here in the 1830s. The panels themselves, divided into twelve compartments, date from the early eighteenth century. In each one a central landscape scene is framed by smaller panels of birds, fruits and figures.

This cabinet, to the left of the fireplace, and the pier glass above conceal a door that leads to the Royal Family's apartments.

Queen Alexandra
François Flameng
1908

It is rare for anatomical accuracy and a sense of stylish
elegance to be combined in a portrait, and this painting is
no exception. François Flameng was a successful Parisian
society portrait painter, and in his image of Queen Alexandra,
King Edward VII's consort, he appears to have elongated and
exaggerated the proportions of his sitter's limbs. In doing so
he was conforming to contemporary fashion. Equally up to
date at the time was the fluid handling of the paint, particularly
the treatment of the fabric of the dress. Compared to all
the earlier portraits on show in the Palace the finish of this
one seems surprisingly cursory. Clearly the artist preferred
a certain vivacity to the meticulous description of detail.
Queen Alexandra, who was 64 when this portrait was painted,
is shown wearing the ribband and star of the Garter, the
traditional insignia of power and rank.

In his younger years King Edward VII had enjoyed the
attentions of numerous beautiful women. Despite this, Queen
Alexandra had the dignity and courage to summon the King's
mistress to his side, tactfully leaving them alone together,
hours before her husband's death.

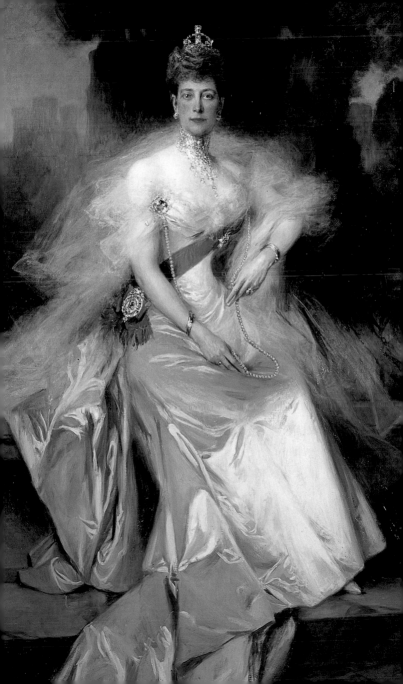

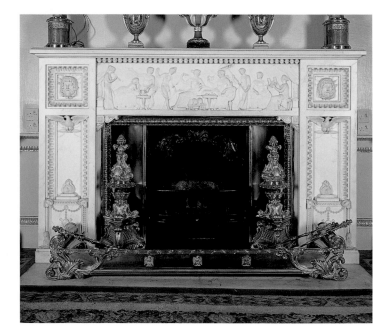

THE WHITE DRAWING ROOM

Chimneypiece
John Flaxman

early nineteenth century

John Flaxman started his career as a designer of pottery
working for the Wedgwood factory. Having studied extensively
in Rome, he gradually built a reputation as an independent
sculptor and draughtsman, winning widespread recognition
for his series of illustrations for the works of Virgil, Homer and
Dante. Later he was involved in the design and construction
of a host of public monuments. He worked for George IV on
several occasions. He crowned his career with his appointment
as Professor of Sculpture at the Royal Academy in 1810.

In the centre of this chimneypiece
a shallow carved frieze depicts an
imaginary scene of classical, homely
bliss with reclining, well-attended figures
enjoying the warmth and nourishment
of the hearth. In the corners appears the
head of Apollo, god of the sun. Beneath
these, on either side, eagles clutching
Jupiter's thunderbolts hover above
flames. In classical mythology these
were forged by Vulcan, the divine
blacksmith. In each case, then, there
is a connection with fire.

Grand Piano
Sébastien and Pierre Erard

mid-nineteenth century

Queen Victoria bought this piano in 1856 from the French makers Sébastien and Pierre Erard. Its gilded case is decorated with scenes of mischievous but musical monkeys, painted by Francis Richards with designs adapted from eighteenth-century French sources.

Queen Victoria had, in the words of one of her Prime Ministers, 'an inordinate fondness for music'. Both she and Prince Albert played and sang well, and enjoyed holding musical evenings at Buckingham Palace. The Queen's favourite living composer was Felix Mendelssohn, who played for the couple both formally and informally on a number of occasions in the 1840s. He presented them with an arrangement for four hands of one of his 'Songs without Words' and described the Queen's voice in a letter to his mother: 'She sang beautifully in tune, in strict time and with very nice expression . . . The last long C I have never heard purer or more natural by any amateur.'

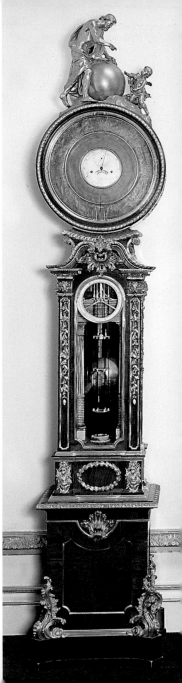

THE MINISTERS' STAIRCASE

Barograph
Alexander Cumming
1765

This barograph (a combination of a clock and a barometer)
is one of the few objects in the State Rooms to survive from
George III's Buckingham House. George III's rooms were
described by a contemporary as 'rather neatly elegant than
profusely ornamental', but this masterpiece combines extreme
precision in the recording of atmospheric pressure with a
degree of ornamentation that was unusual in English scientific
instruments of the time. An inked stylus linked to a vessel
of mercury recorded the air pressure on the vellum dial
surrounding the clock face.

The barograph cost the King £1,178. It is made from
mahogany and kingwood with gilt bronze mounts; the interior
supports are of carved ivory. At the top, a gilt bronze figure
represents Time, with an open book resting on a sphere next
to a figure of Cupid.

George III was the first British King to be educated in
the sciences. He believed that it was the monarch's duty to
promote scientific knowledge, since control of the overseas
Empire depended upon it, and he was obsessed with the
fortunes of the Royal Navy, in whose hands so much of
Britain's security lay. He regularly consulted the weather to find
out how it might be affecting his fleet and kept nautical charts
in his Library.

George, Prince of Wales
John Hoppner
c.1796

John Hoppner was a successful, fashionable portrait painter in late eighteenth-century London (see p. 129). Born of German parents, he was recommended to George III as a young man and was initially well received by him. Subsequently he was rumoured to be his illegitimate son, although there was no evidence for this. For whatever reason, he fell out with the King in 1795 and became painter to the Prince of Wales. This portrait of the Prince of Wales, the future George IV, was probably commissioned for the Throne Room at Carlton House.

The Prince is shown in Garter robes (see p. 137), holding the plumed hat of the Order in his right hand. Although the current arrangement at Buckingham Palace was organised by Queen Victoria, George IV had always wanted a series of family portraits to hang in the State Rooms at Carlton House. To this end he had commissioned works by a number of contemporary painters. George IV also encouraged contemporary artists indirectly by supporting the efforts of John Julius Angerstein, another of Hoppner's sitters and a founder of Lloyd's, to establish the National Gallery.

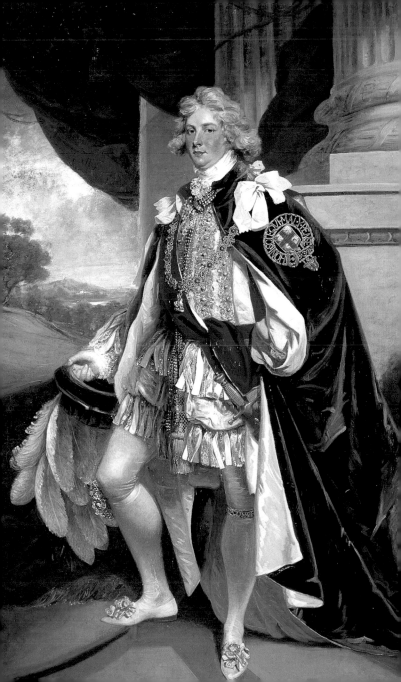

Mars and Venus
Antonio Canova
c.1815–17

In 1818 Lord Byron declared the sculptor Canova to be
the equal of any of Italy's greatest artists from the past.
His opinion was generally accepted and Canova enjoyed
exceptional success and renown. He was based in Rome,
where he produced many sculptures for the Bonaparte
family, including a scandalous nude portrait of Napoleon's
sister, Pauline, posed as Venus (goddess of love). Following
Napoleon's defeat in 1815 Canova visited England and
George IV, then the Prince Regent, promptly commissioned
him to carve this statue.

In classical mythology, Mars (god of war) and Venus
indulged in a notorious affair. Ever since, the pair have been
depicted as the perfect romantic couple. Their relationship
has often been allegorised: brute male aggression tamed by
feminine beauty and charm. Here Canova dramatises the story
using clearly legible poses and gestures. Mars has just turned
from an upright, soldierly stance to face an alluring, curvaceous
Venus. He is naturally about to yield to her entreaties.

The two figures are carved from a single block. Their
anatomy is idealised, according to the standards of classical
sculpture. What Canova adds, in the way he carves the marble,
is his own alluring sensitivity to the softness of human flesh.

Chinese Vase

early twentieth century

This pair of vases was a gift to King George V and Queen Mary
on the occasion of their coronation in 1911. They were
presented by Puyi, the last Emperor of China. The vases are
made from cloisonné enamel. This is an ancient technique:
the earliest examples were made in Mycenaean Greece about
1450 BC. Strips of metal are fixed or soldered to a shaped
metal surface to provide the basic form. The spaces between
are filled with powdered glass – the name 'cloisonné' comes
from the French word meaning partition or gap. The whole
object is then fired, smoothed and polished – a process
fraught with risks for vases of such large proportions.

It is doubtful that the Emperor Puyi had any involvement
in choosing this magnificent gift; he was only 5 years old at
the time. He was the last of the Qing emperors, who had
ruled China since invading from the north in the seventeenth
century. It is ironic that these vases should celebrate the
beginning of a new reign; in 1911 the Qing dynasty fell
and the Emperor was confined to the Forbidden City.

The vases are decorated with writhing dragons. Dragons
were the most powerful of the Chinese mythological animals
and were often used to represent the emperor.

M.W.

Steel Table
Placido Zuloaga
1880

At least one English dictionary traces the origin of the phrase 'blue blood' to sixteenth-century Spain, where it was noted that the whiter a person's skin, the more blue did the veins under its surface appear. Such effects were important to those families who were anxious to prove that their pedigree was not simply noble but free from the taint of Moorish ancestors.

By the nineteenth century the situation was rather different. The Spanish metalworker Placido Zuloaga actively sought to revive Moorish design and ornament. His fame largely rests on damascened metalwork – that is, metalwork where gold or silver is inlaid into steel – of which this table is a fine example. It was made for Alfred Morrison, and the owner's cipher is visible on the side panels. It was subsequently bought by Queen Elizabeth the Queen Mother in 1938. The top is of green marble with a steel border, inlaid gold arabesques and bosses of lapis at the corners. The frame is also inlaid and gilded. Such easily damaged surfaces indicate that the table was made for display rather than for everyday use.

Queen Victoria
Franz Xaver Winterhalter
1859

While Prince Albert was a well-informed collector of Old Master paintings, Queen Victoria enjoyed commissioning pictures, mostly portraits, from contemporary artists. Among her favourites was the German artist, Franz Xaver Winterhalter. He went on to paint over one hundred works for her. Winterhalter also taught both Queen Victoria and Prince Albert to paint.

This portrait and that of Prince Albert (p. 205) were declared official likenesses. The Queen is shown seated, in full state robes. She contrives to appear both grave and alert, with her left hand holding a sheaf of important-looking papers that lie next to the crown. In the background is a view of the towers of Westminster Abbey and the Houses of Parliament: a reminder of the entwined roles of monarch and parliament. It can also be seen as a deliberate reference to the background of Van Dyck's portrait of Charles I (see p. 77). We also look up at the Queen, while her head dominates the buildings behind; in this way Winterhalter was able to pay his respects to past portraits while expressing deference to the present monarch.

THE MARBLE HALL

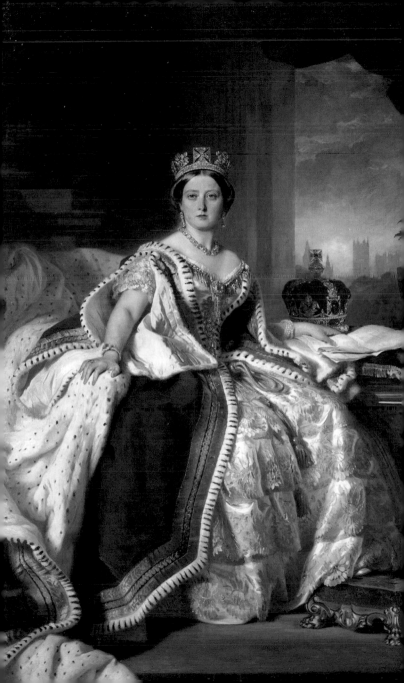

Prince Albert
Franz Xaver Winterhalter
1859

This portrait was painted at the same time as the one of Queen Victoria nearby (p. 203). Both were official images, intended to be seen together. The fanciful architectural setting is effectively the same in both. Numerous copies and other reproductions of them were made.

Prince Albert is shown standing; the Queen is seated. But while she wears ceremonial, regal dress, he wears the less exalted uniform of a Colonel of the Rifle Brigade. Furthermore, there are no instantly recognisable national or institutional buildings behind him. And while her crown stands upright, his hat rests on its side. In this way discreet recognition is given to the respective differences of sex and rank.

Even so, Prince Albert has good reason to appear confident. Draped behind him are the robes of the Order of the Garter and a field marshal's baton. He wears the ribband and the star of the same Order (see p. 137) and the badge of the Golden Fleece. Recognition is also afforded to his learning, signalled by the books and stacked portfolios to the right, without letting him appear too erudite or bookish.

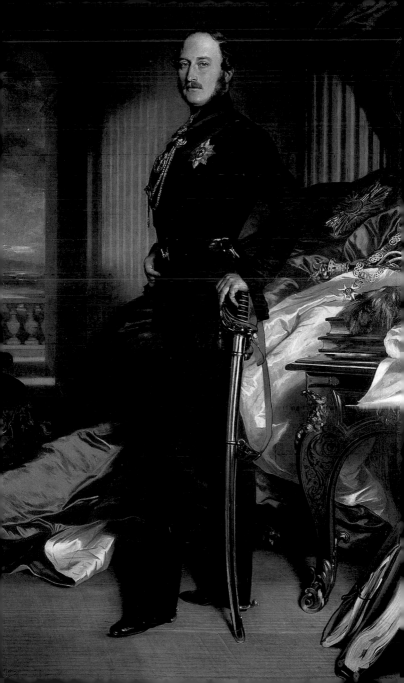

Gilt Table
James Moore
c.1715

The robust, solid proportions of this table set it apart from the furniture acquired by George IV for Buckingham Palace. It also lacks the gilt bronze mounts, inlaid marquetry and veneered woods of many French pieces acquired by him later. One of a pair, it was made for George I, whose cipher is prominently displayed in the centre of the elaborately carved apron, topped

with a crown and circled with the motto of the Order of the Garter (see p. 137).

The table is of English manufacture and was made by James Moore, a specialist in this kind of work. Some of the decoration – on the frieze and on the legs – was carved out of wood. The top surface was created by applying several layers of gesso – a mixture of gypsum (plaster of Paris), linseed oil and glue – which was then cut into and carved with fine detail. The whole surface was then gilded. Although impressive and expensive to make, such 'golden' furniture was considerably cheaper than the solid silver furniture made for Louis XIV that so impressed visitors to Versailles.

This table is one of the finest examples of its kind. Moore made other pieces in gilt gesso for the King which are now both here and at Hampton Court Palace.

Fountain Nymph with Putto
Antonio Canova
1817–18

This piece was commissioned by Lord Cawdor after he had seen the notorious sculpture in Rome, carved by Canova, of Napoleon's sister Pauline Borghese reclining nude on a sofa (see p. 196). Having fallen for its wanton charms, he immediately requested this piece from the sculptor, demanding a work similar to that of the shameless Pauline.

Originally the sculpture was intended to form part of a fountain. The water was to flow out of the rock upon which the nymph leans and upon which she has been sleeping; she has evidently been awoken by the harp played by the putto. The lion's skin seems to be a reference to the mythological hero Hercules, who wore one as a garment.

Later Lord Cawdor magnanimously agreed that the sculpture should go to George IV. The Regent placed it at Carlton House in the Gothic Conservatory – along with his other Canovas. The setting must have appeared extraordinary. The conservatory was an extremely ornate construction based on the chapel of Henry VII at Westminster Abbey – far, far removed from the immaculate, smooth and languid perfection of Canova's Neoclassical style. Here, though, the nymph was protected from lascivious or curious hands by brass railings tipped with spikes.

Chelsea Porcelain Plate

c.1763

> *I saw yesterday a magnificent service of Chelsea china,*
> *which the King and Queen are sending to the Duke*
> *of Mecklenburg. There are dishes and plates without*
> *number, an epergne, candlesticks, salt-cellars, sauce-*
> *boats, tea and coffee equipages; in short, it is*
> *complete; and cost twelve hundred pounds! I cannot*
> *boast of our taste; the forms are neither new, beautiful,*
> *nor various. Yet . . . the manufacturer is French.*
> *It seems their taste will not bear transplanting.*

So wrote Horace Walpole in 1763, referring to this service.
It was given by George III and Queen Charlotte to the Duke
of Mecklenburg, the Queen's brother. It was sold by the
Duke's descendants and was subsequently presented to
Queen Elizabeth the Queen Mother in 1948.

It was the most elaborate service ever to have been made
in England – although, to be strictly accurate, the craftsman
overseeing the work at Chelsea, Nicholas Sprimont, was
French. The underglaze decoration is in a deep
'mazarin' blue, with gilding and painted flowers,
birds and butterflies applied over the
glaze. Earlier on, continental porcelain
manufacturers had used tiny
painted insects or birds to hide
faults in the glaze. In this
service the painters used
a profusion of similar
decorative motifs
simply for their
own sake.

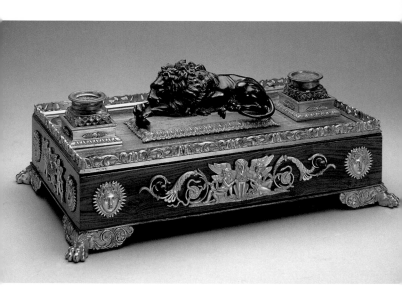

Lion Inkstand

c.1815

The reclining lion on this inkstand is a reduction in bronze of the full-scale lions made by Antonio Canova for the tomb of Pope Clement XIII in St Peter's in Rome. Canova himself described its attitude as one of 'deepest sorrow'.

George IV was not alone in his great admiration for Canova's work (see p. 196), but for the sculptor the good opinion of such a prominent patron brought him, as he put it, a 'halo of glory'. He was one of the first artists to be famous (even to the extent of being recognisable) throughout Europe in his lifetime. Of all his works, these two lions were perhaps the most widely

reproduced in miniature, helping to spread the sculptor's renown across Europe in the years before photography.

The inkstand is one of a pair. Both are made of mahogany, veneered with kingwood and decorated with gilt bronze mounts. They were originally kept in George IV's private apartments at Carlton House.

Incense Burner and Pedestal

late eighteenth century

Perfume or incense burners were once a necessary component
of any grand, well-appointed room. As a magazine writer of
1793 put it in an article describing the furnishings at Carlton
House, incense burners were to provide 'an agreeable smell
[which] may be diffused to every part of the room, preventing
that of a contrary nature, which is the consequence of lighting
a number of candles'. In other words, like the vases of pot-
pourri, they counteracted the smell of burning grease or wax
produced by even the most expensive kinds of candle.

This pair was actually bought by Queen Mary in 1924,
though they date from the end of the eighteenth century.
They are made from oak and veneered in a lozenged,
reeded pattern with mahogany, sycamore, walnut, satinwood
and ebony. Exotic gilt bronze mounts add a discreet note
of decoration.

When pulled outwards the handles on the pedestals reveal
three decorated steps by which a servant could climb up to
light the scented pastilles. Turning the gilt rosette on the urn
opens the burners themselves. The smoke would then disperse
through the small pipes above.

The Gates to Buckingham Palace

1914

The principal gates form part of the overall scheme for the east front and approach to Buckingham Palace designed by Aston Webb in the early years of the twentieth century as the national monument to Queen Victoria. The gates were designed and made by the Bromsgrove Guild of Metalworkers, based in the Midlands.

The royal arms adorn both of the main gates. These arms have developed over several hundred years, though their current appearance dates from the time of Queen Victoria. The central shield is divided into quarters which represent the kingdoms of England, Scotland and Ireland (England is shown twice). The shield is surrounded by the Garter, symbolising the Order of the Garter, founded in 1348. The arms are supported on either side by a lion and a unicorn. Supporters first appeared in the fourteenth century but these date from 1603. Above is the royal crest: a lion standing on a crown, introduced by Henry VIII, and below is the motto *DIEU ET MON DROIT* (God and my right), first used by Henry V.

Exuberant palm leaves, the classical symbols of victory, surround the royal arms. Even more dynamic are the cherubs grouped around the locks to the gates (see p. 218). These add, albeit on a diminutive scale, an unexpectedly playful note to the solemn monumentality of the Palace's outward, most public face.

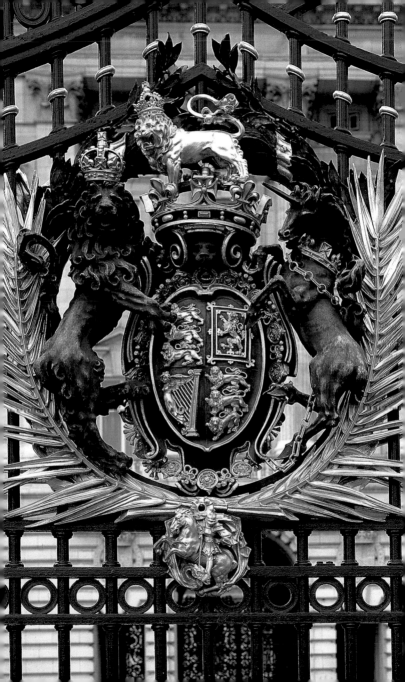

The lock to one of the gates of Buckingham Palace

Further Information about the Royal Collection

This book is intended to introduce the reader to some of the most interesting items to be seen at Buckingham Palace. There are many other publications that give further details on different aspects of the Royal Collection. Details of some of them are given below. If you would like to receive a catalogue of current publications, please write to the address below, or visit our website on www.royalcollection.org.uk

Royal Collection Enterprises Ltd
St James's Palace
London SW1A 1JR

For tickets or more information on the Summer Opening of the State Rooms at Buckingham Palace, please contact:

Ticket Sales and Information Office
Buckingham Palace
London SW1A 1AA

Credit card booking office (+44) (0)20 7766 7304
Group bookings (+44) (0)20 7766 7321
Fax: (+44) (0)20 7930 9625
Email: information@royalcollection.org.uk
groupbookings@royalcollection.org.uk

History

H. Clifford Smith, *Buckingham Palace*, London 1931.

J. Russell, J. Harris, G. de Bellaigue, O. Millar,
Buckingham Palace, London 1968.

R. Simon (ed.), *Apollo*, 'Buckingham Palace,
A Complete Guide', London 1993.

E. Healey, *The Queen's House, A Social History of Buckingham Palace*, London 1997.

C. Lloyd, *The Paintings in the Royal Collection*, London 1999.

J.M. Robinson, *Buckingham Palace. The Official Illustrated History*, London 2000.

Biographies

J. Pope-Hennessy, *Queen Mary, 1867–1953*, London 1959.

C. Woodham-Smith, *Queen Victoria: Her Life and Times*, London 1964.

J. Brooke, *King George III*, London 1972.

O. Hedley, *Queen Charlotte*, London 1975.

G. and M. Scheele, *The Prince Consort*, London 1977.

E.A. Smith, *George IV*, Yale 1999.

Exhibition catalogues

London, The Queen's Gallery, Buckingham Palace, *George III, Collector and Patron*, 1974–5.

London, The Queen's Gallery, Buckingham Palace, *Sèvres Porcelain from the Royal Collection*, 1979–80.

London, The Queen's Gallery, Buckingham Palace, *Treasures from the Royal Collection*, 1988–9.

London, The National Gallery, *The Queen's Pictures. Royal Collectors Through the Centuries*, 1991.

London, The Queen's Gallery, Buckingham Palace, *Carlton House, The Past Glories of George IV's Palace*, 1991–2.

London, The Queen's Gallery, Buckingham Palace, *The Quest for Albion. Monarchy and the Patronage of British Painting*, 1998.

Cardiff, The National Museum and Gallery, *Princes as Patrons*, 1998.

London, The Queen's Gallery, Buckingham Palace, *Royal Treasures*, 2002–3

Index

INDEX

First published 2000 by Royal Collection Enterprises Ltd
St James's Palace, London SW1A 1JR

Revised by Royal Collection Enterprises Ltd. 2003, 2008

© 2008 Royal Collection Enterprises Ltd
Text by Tom Parsons, Kathryn Barron and Matthew Winterbottom,
and reproductions of all items in the Royal Collection
© 2008 HM Queen Elizabeth II
107383

ISBN 978 1 902163 92 5

British Library Cataloguing in Publication Data.
A catalogue record of this book is available from the British Library.

Production by Debbie Wayment
Designed by Mick Keates
Printed in Singapore by C.S. Graphics Pte Ltd.

COVER ILLUSTRATIONS
Main illustration: Pierre-Philippe Thomire, Apollo Clock (p.148)
Inset illustrations (top to bottom):
John Hoppner, *George, Prince of Wales* (p.194);
Francis Chantrey, *Mrs Jordan and Two Children* (p.110);
Morel and Seddon, Pietra Dura Table (p.116);
Sèvres, Pot-pourri Vase (p.42);
Guercino, *The Libyan Sibyl* (p.58)
Back: Jan Vermeer, *'The Music Lesson'* (p.68)